IMAGES
of America

WINN PARISH

Bought this book in the
Summer of 011 at the political
museum in Winnfield, La

Stephen R. Satch

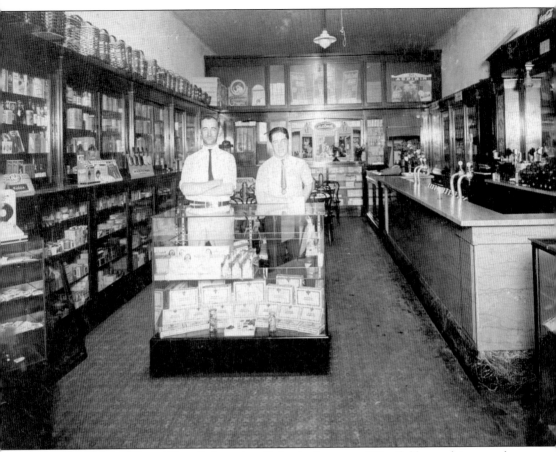

ON THE COVER. When folks talk about the old days in downtown Winnfield, nostalgic remembrances inevitably include Porter's Drugstore and his soda fountain, where young couples could enjoy malts, milk shakes, and of course, his famous Cherry Nectar. In this photograph are Dick Porter (left) and Glen Anderson. (Courtesy Sara Shell.)

IMAGES of America

WINN PARISH

Bob Holeman and
Friends of the Louisiana Political
Museum Foundation

ARCADIA
PUBLISHING

Published by Arcadia Publishing
Charleston, South Carolina

Printed in the United States of America

Library of Congress Control Number: 2010930926

For all general information, please contact Arcadia Publishing:
Telephone 843-853-2070
Fax 843-853-0044
E-mail sales@arcadiapublishing.com
For customer service and orders:
Toll-Free 1-888-313-2665

Visit us on the Internet at www.arcadiapublishing.com

*To the residents and pioneers of Winn whose
passion for history inspired this publication*

CONTENTS

ACKNOWLEDGMENTS

Winn Parish has a rich and colorful history as well as residents who appreciate that history. The Louisiana Political Museum, housed in Winnfield—the home of three governors—strives to amass and protect as much of that history as possible, so the offer to work with Arcadia Publishing to produce this volume of historic photographs was seen as a wonderful opportunity.

This excellent collection would not have been possible without the loans and permission to use hundreds of classic photographs from residents and former residents of this parish, to whom The Friends of the Louisiana Political Museum and Hall of Fame Foundation say, "thank you." Pulling those pictures together and organizing, selecting, and identifying them was accomplished through the diligence of the Book Committee, including June Melton, Mary Nell Milam, Jim Pinkerton, Jane Purser, and Linda Talbert.

Many individuals have been gracious in their response to the call for help during the historical research phase of this book, and the Friends thank them all. The "Friends of the Museum" is truly indebted to two other committee members in particular, Greggory Davies and Raymond Carpenter, for both the photograph resources and the historical backgrounds. In our research, we have leaned heavily on historian Davies and the huge body of historical work he has accumulated through the Winn Genealogical & Historical Association and its related Web site, www.usgwarchives.org. Raymond Carpenter, through his decades of work as pressman for the *Winn Parish Enterprise*, scanned hundreds (or perhaps thousands) of historic photographs as they came in and spent countless hours saving and cataloging that work. Many of the photographs in this book are a part of the *Winn Parish Enterprise* Collection. All photographs not attributed to others come from this collection.

Committee members responsible for the final assembly of the book are museum director Carolyn R. Phillips, who provided significant background and insight during the writing phase; museum administrative coordinator Angelia Tullos, who provided the technical computer skills for quick research and compilation; and former *Enterprise* publisher Bob Holeman, who pulled together the many facts, thoughts, and ideas into readable text.

To all, the Friends of the Museum say, "thank you."

INTRODUCTION

Casual research will reveal Winnfield and Winn Parish as the birthplace of "the Kingfish," populist demagogue Huey P. Long, who vowed to "Share Our Wealth" and make "Every Man a King" in his quest for the White House.

History scholars assert that Winn has embraced more history during its first 150 years than any other part of Louisiana, with the exception of New Orleans. It is a history appreciated by residents, one rich in individuals and events that would leave their marks on the entire nation.

Winn was born poor, 1,500 square miles of inaccessible virgin pine wilderness carved from three surrounding parishes by the state legislature in 1852. (Winn would have to give back one-third of that acreage 16 years later, when Federal loyalists were rewarded in the wake of the Civil War by the creation of a new parish named for Gen. Ulysses S. Grant.)

History was being written here long before that 1852 legislation was penned. For centuries, Indians followed trails from as far away as Rhode Island to enjoy the saline waters and the salt that could be extracted from what is now known as Drake's Salt Works. Reuben Drake developed an oxen-powered rotary drill. His innovation utilized a bit fashioned from tempered hickory and hollow cypress log casings to bore deepwater wells that were used to hasten the salt evaporation process. This opened the door for an infant oil industry when Reuben's cousin Edwin Drake employed that same technology in Titusville, Pennsylvania.

Salt has been a major player in world history. Winn's greatest salt deposit would prove to be not these historic springs, valued through the Civil War, but a nearby salt dome that would wait another half century before being discovered. Louisiana has many salt domes, and one just west of Winnfield is capped just 440 feet below the surface. In early 1931, Carey Salt opened its mining venture with an 811-foot shaft and began production that bolstered the local economy until November 17, 1965, when the mine flooded without loss of life.

Winn was still a young parish when civil war in this nation was fomenting. The general sentiment of Winn's early settlers was against secession, and Rep. David Pierson voted "no" to support those feelings during the Baton Rouge secession convention in 1861. But the "Free State of Winn" was no sign of political indifference among the citizenry, as over 1,000 young men, Pierson among them, with true fidelity joined the Confederacy. A number also joined the Union cause.

Casualties in the country's struggle were high, and demoralization enveloped the nation. The inequities of heavy-handed Reconstruction tactics saw the rise of the ruthless West-Kimbrell Clan here. Historian Harley Bozeman theorized that the clan originated as a home guard to protect the area from the exploits of Union occupiers. Sadly, John West, Laws Kimbrell, and others of their inner circle expanded the terror to prey on many innocent travelers. The reign ended with a Sunday morning shootout and hanging in Atlanta, Louisiana. The gang was buried alive, but legends survive, including that of the "Lost Spanish Gold."

Through its first five decades, Winn's economy languished as small numbers of early settlers survived on subsistence farms hewn from the forests, and only a handful of rural stores existed

to support them. The door to a thriving economy was unlocked at the beginning of the 20th century with the arrival of railroads to transport vast timber resources to a waiting American market. Trees were no longer an obstacle—they were an asset. In 1901, the Arkansas Southern work train was the first to pull into Winnfield, and within five years, there were as many railroads transporting goods and providing service for the community.

By 1910, Winnfield was a booming metropolis with a cosmopolitan population. Its business district, radiating from the railroad depot, boasted everything modern man could want—hotels, boardinghouses, retail stores, fresh meat and vegetable markets, restaurants, tailors, cobblers, jewelers, doctors, lawyers, and even an opera house.

Rail, with its boom, was good for outlying Winn as well. With rail spurs and a seemingly unending timber supply, lumber mills sprang up across the parish. Dodson and Atlanta blossomed, while others like Calvin, Sikes, Coldwater, Joyce, Fay, Loftin, Tannehill, Ringwood, and Winona grew as well. Unfortunately, when all timber proximate to the mills was clear-cut and the supply exhausted, many mills closed. Their support communities suffered or disappeared altogether. As the seat of government and the main railhead, Winnfield managed to survive.

The seeds of Winn's political culture may have been sown in the heavy toll of the Civil War and the resentment of the Reconstruction years that followed. They were manifested in the Farmers Union and later the Grange Movement of the 1870s and the Populist Movement of the 1880s and 1890s. All were embraced by area residents.

The working people of Winn Parish had a cause, and they were waiting for a prophet. They found that prophet in a brash young hometown boy named Huey Long, who made a meteoric rise to statewide attention as a railroad commissioner. His quest for power was insatiable; he was elected governor and then senator. Taxing Standard Oil to build roads, bridges, and public hospitals across the state and to provide free textbooks for the children, Huey gathered a Depression-ravaged base of support through his Share Our Wealth Society. He was gunned down in 1935 as he was mounting his campaign for the presidency against incumbent Franklin Roosevelt. (Confident of victory, Long had already written his book, *My First Days in the White House*.)

In spite of his death, Huey had already imbued state government with so many friends and family that the "Long Dynasty" continued to wield tremendous influence over Louisiana politics for decades to come. Winn would be home to three Democratic governors, including his handpicked successor Oscar Allen and brother Earl K. Long.

In 1941, Louisiana was selected as the staging grounds for the largest war games exercise ever undertaken by US troops. Winn was at the heart of the Red Army's think tank during the Louisiana Maneuvers, with both George Patton and Dwight Eisenhower spending much of their time here. The state saw an influx of 500,000 soldiers, and Winn accommodated the young men as best it could. Their presence here impacted the economy and made lifetime impressions on those who witnessed it.

Winn's history has been a multifaceted tapestry of happenings and events. But it has taken its people, through their homes, businesses, industries, schools, churches, and organizations, to stitch together this tapestry and create a true community. This book will provide our readers an appreciation of the rich history of Winn Parish.

—Friends of the Louisiana Political Museum

One

FORESTRY SHAPES ECONOMY

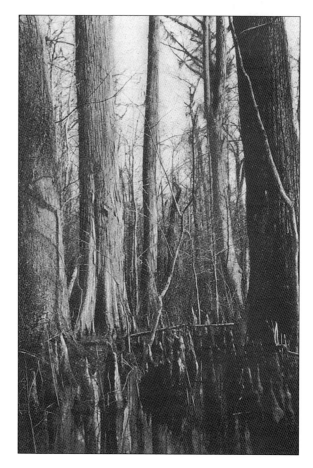

Winn Parish was carved from three surrounding parishes (Natchitoches, Rapides, and Catahoula) by a legislative act in 1852. At that time, timber was an obstacle. This 1898 photograph by the US Geologic Survey shows a towering virgin cypress stand at Coochie Brake.

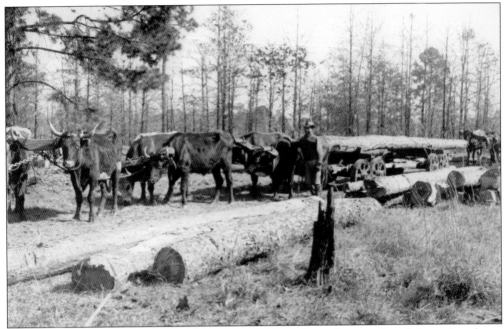

In the early days of Winn's timber industry, logging was a tedious and work-intensive chore. The massive virgin pines were felled by hand, then dragged and rolled to heavy animal-drawn wagons. Trees of the first forest were often so large that a single log would make up the entire load, as shown in this photograph of a Bentley Lumber Company team of oxen. (Courtesy George Tannehill Collection.)

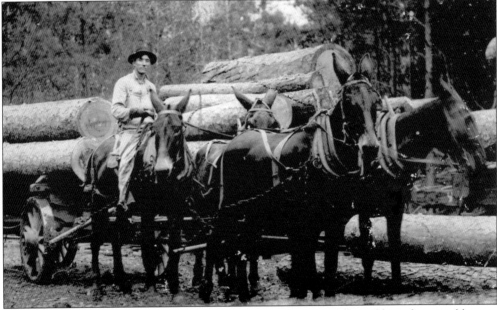

The arrival of railroads in Winn Parish made logging economically viable and many able men became involved. The mule proved to be a reliable beast of burden for hauling log loads from the forests to railheads. In this 1907 photograph, Tate White uses his mule team to deliver a three-log load to the railroad, visible in the background. (Courtesy Walter White Jr.)

In those days, tracts were clear-cut with no efforts made to replant. Natural regeneration was all there was. Even so, there were still some areas where virgin pine flourished in pre-Depression Winn. Logs like those in this photograph were often several feet in diameter and were choice timber for the huge lumber mills that had sprung up all across the parish. (Courtesy Louisiana Political Museum.)

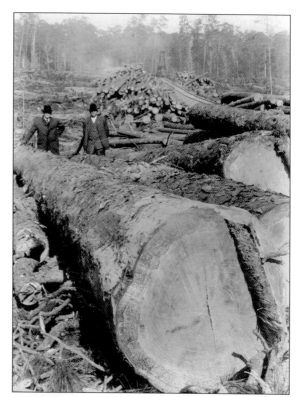

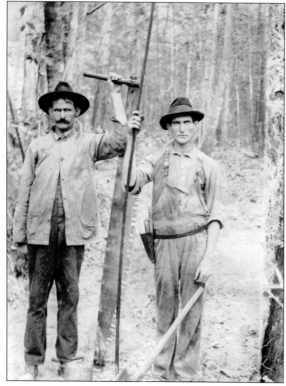

This photograph illustrates clothing and equipment typical to loggers of the early Winn timber industry. Included are a two-man crosscut saw, wedges worn in a belt around the waist, a steel rod, and a double-bitted axe. This was not an occupation for the weak or timid.

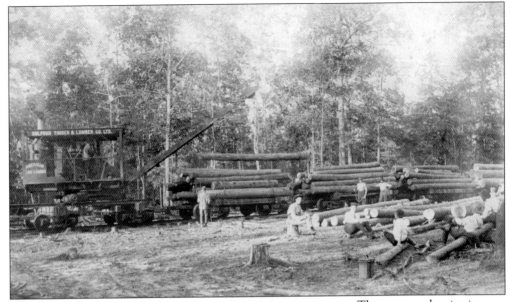

The next modernization of timber harvesting came with the mounting of a mechanical skidder on a railcar. By using a strong cable and a powered wench, logs were pulled—or skidded—from where they were cut down to the waiting train and then loaded onto the flat cars for transport to mills. (Courtesy June Melton.)

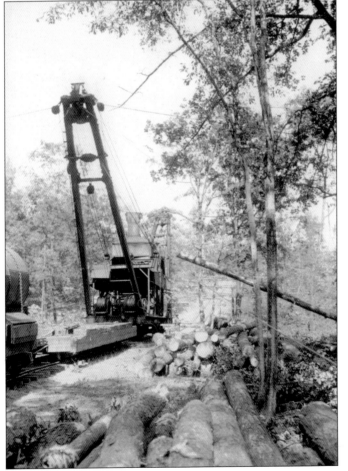

This is a front view of a loader called a Logger's Dream. A log is being pulled towards the tracks, where it will be loaded onto the train. In some areas, temporary tracks were laid through the woods of Winn so that skidders could provide efficient timber removal. Once all trees within range of the cables had been removed, those tracks could be taken up. (Courtesy US Forest Service.)

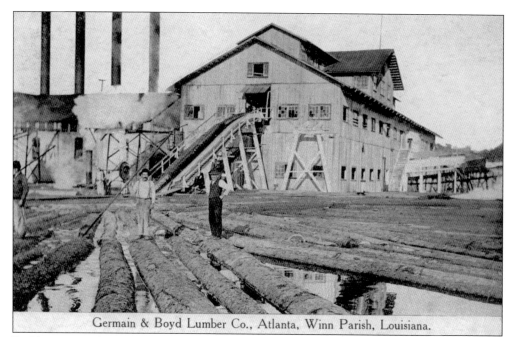

Germain & Boyd Lumber Co., Atlanta, Winn Parish, Louisiana.

Rail lines opened Winn to logging, and mills sprang up as a result. Five railroads, with many spurs running to the mills, served the parish. Germain & Boyd Lumber Company in Atlanta, Louisiana, was the largest of them all. Mills thrived as long as the timber supply in their immediate area held out. Most mills, including Germain & Boyd, disappeared when the supply was depleted. (Courtesy Greggory Davies.)

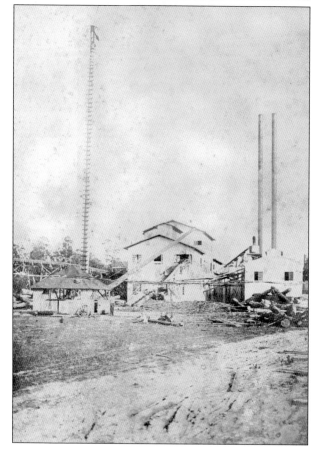

This 1936 photograph shows the first site of Mansfield Hardwood Lumber Company on Highway 167 South. It was the only mill in Winn Parish to process the hardwood timber of lowlands and creek bottoms. The operation later relocated to Front Street in Winnfield. Its manufacture shifted from hardwood to pine production when hardwood timber became limited.

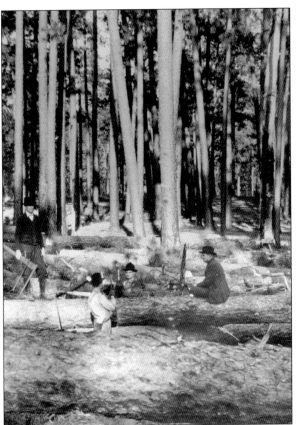

In the early 1900s, the concept of reforestation and plantation stands began to provide a continuous supply of timber. Superior timber could be grown by cutting out small trees and underbrush that inhibited the growth of the stronger trees. Tremont Lumber Company in Joyce was one of the earliest companies to capitalize on this novel environmental idea. (Courtesy Louisiana Political Museum.)

FDR's New Deal in Depression-strapped America included the CCC (Civilian Conservation Corps), which employed men ages 18 to 24 on works projects while they lived in camps. Their work included tree planting in the Kisatchie Prairie and other deforested areas of Winn. The CCC planted over 165 million trees in Louisiana alone. National and state forests were later carved from areas they preserved. (Courtesy George Tannehill Collection.)

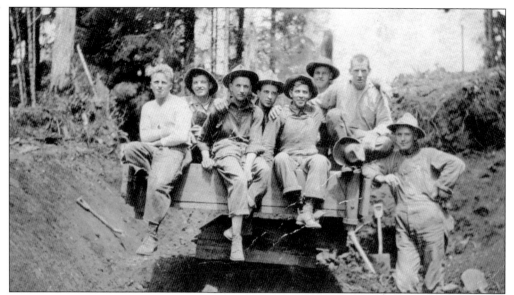

Work by CCC crews around Winn Parish extended beyond reforestation. Meaningful employment also encompassed erosion abatement, the building of trails, bridges, and fences, recreational improvements at Gum Springs, and mosquito control. The CCC was truly a great American experiment. In addition to food and lodging, each enrollee received $30 each month, but $25 had to be sent home to help the family. (Courtesy Helen Maloy.)

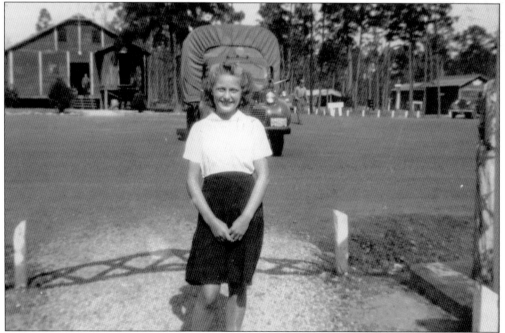

There were five CCC camps in Winn Parish in a nine-year program that ensured an unending supply of manpower for public works projects. Sites here included Dodson, Calvin, Gum Springs, and two in Winnfield. During that period, over 51,000 people served throughout Louisiana. In this photograph, Trudy Moore Shecton poses at the front gate of the Calvin CCC camp. (Courtesy Kathy Guin.)

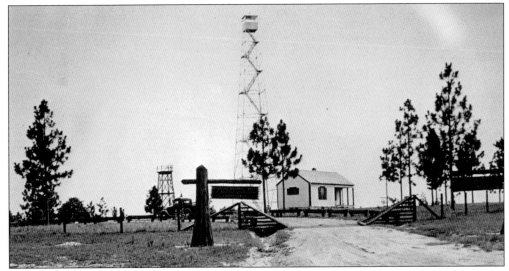

As part of their chores, CCC workers built Gum Springs Recreation Area and the fire tower, fences, and buildings within Kisatchie National Forest. This recreational area went on to serve thousands of people through the years. In this 1937 photograph, a sign outside the cattle gate heralds the Kisatchie National Forest ranger station. The fire tower dwarfs the simple station. (Courtesy George Tannehill Collection.)

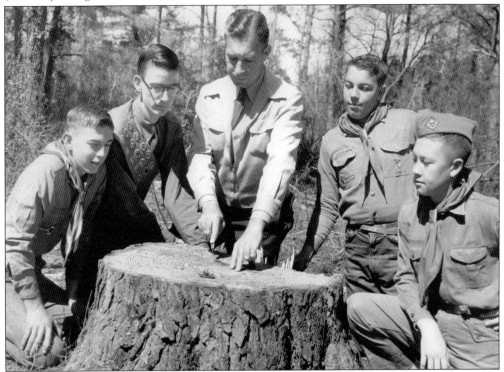

George Tannehill, for 38 years with the Winn Ranger District, was instrumental in developing the Kisatchie National Forest. A legend in the US Forest Service, Tannehill was more familiar riding his horse through the district, but in this image, he is working with, from left to right, Boy Scouts Lyndall Stanfill, Jerry Miller, Troy Mixon, and Truitt Holcomb. (Courtesy US Forest Service.)

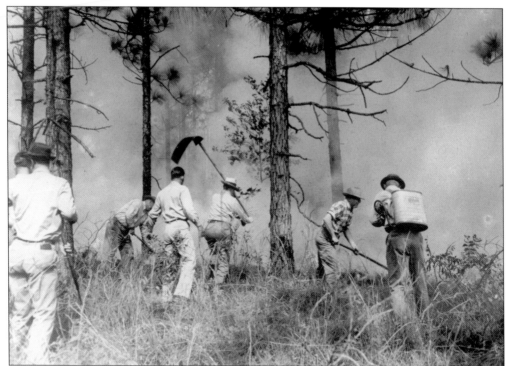

Firefighting in the early days was accomplished strictly by hand. Before mechanization, aerial chemical retardant drops, fire lanes, and back-burning technology, raw manpower was the ticket. In this scene, volunteers and Forest Service personnel (without fire protection gear) use shovels, hoes, and bats with leather flaps to control a blaze in a pine plantation.

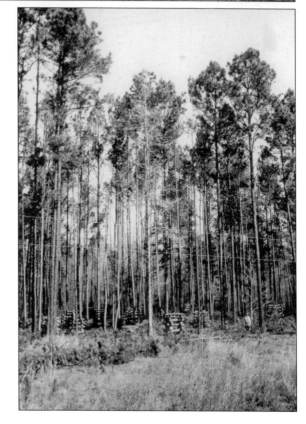

Pulpwood, small-diameter timber, is an essential supply of the chip and paper industry. This pulpwood stand illustrates how good timber management aids rapid growth of tall, straight trees. Since wood in this era was all loaded by hand, it was cut into four-foot lengths so it could be easily loaded. The wood is stacked in piles called billets. (Courtesy US Forest Service.)

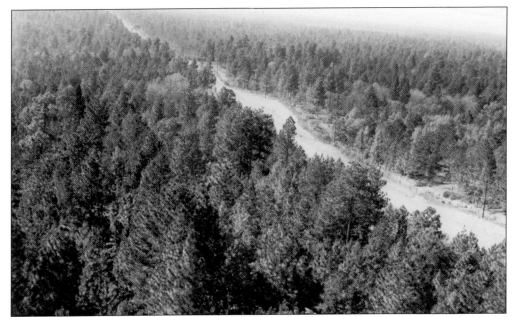

Early timber harvest practices left a landscape around Gum Springs that was desolate and treeless. Replanting of what would become Kisatchie National Forest was undertaken by CCC crews as part of FDR's New Deal of the 1930s. This photograph from atop the Gum Springs fire tower in the early 1950s picturing Highway 84 West shows the success of that program, proof that timber is truly a renewable resource. (Courtesy Bank of Winnfield.)

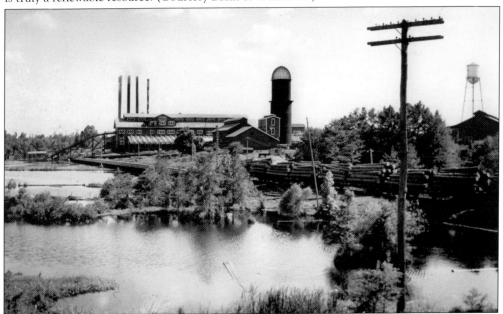

The Tremont Lumber Company at Joyce has had a tremendous impact on Winn's economy. Established in 1899, when virgin timber was at its peak, Tremont was a giant in the region and had its own rail line, Tremont and Gulf (T&G), to transport logs from its timberlands to its mills, with other mills at Rochelle, Dodson, and Pyburn. This photograph is of the Rochelle mill, similar in design to the Joyce mill. (Courtesy Louisiana Political Museum.)

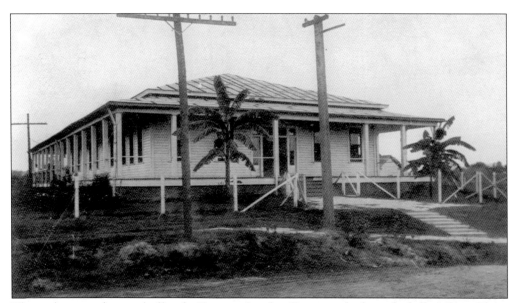

This is the second general office for Tremont Lumber Company, built on the hill on Front Street facing the mill. The first, located on the mill side of the street, was destroyed by fire, as was this in later years. At one time, to prove the impact of the mill on the local economy, employees were paid with $2 bills. Come payday, they flooded local stores and banks. (Courtesy Louisiana Political Museum.)

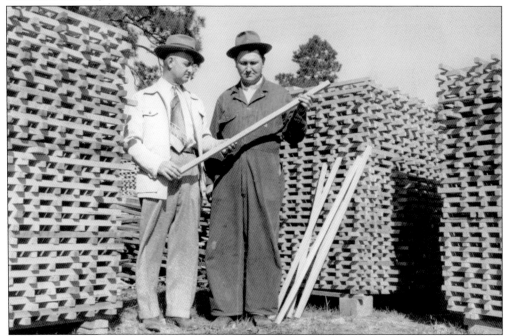

Timber mill pioneer L.L. "Latnie" Brewton Sr. opened his first lumber mill in Goldonna. In the early 1950s, he moved the mill to Laurel Heights on Halsey Street, where operations continued until around 1968. Pictured at his Laurel Heights mill with longtime employee John Wallette, Brewton examines a lumber drying stick, used to provide space between boards for air-drying. (Courtesy US Forest Service.)

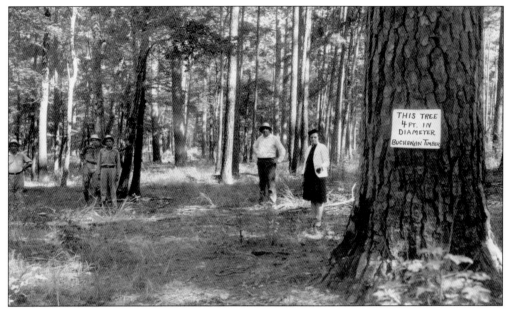

Timberland management became a profitable practice through the years as timber companies and private owners learned the value of thinning and understory control to produce larger trees in a shorter time. In many cases, timber management on private land was provided by company foresters. Such is the case in this scene, with Tremont foresters on Buchanan property. (Courtesy Tremont Lumber Company.)

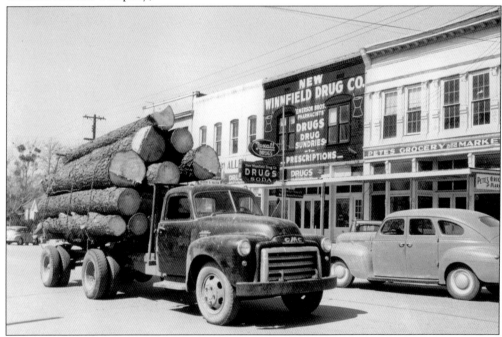

Harvested pine logs are hauled down Main Street through downtown Winnfield on the way to the sawmill, likely Tremont Lumber Company. The large size of the logs on the truck was typical for the second forest, which is smaller than virgin timber of the first forest but still larger than the third forest, planted in the 1970s. (Courtesy US Forest Service.)

Two

RAILROADS AID COMMERCE

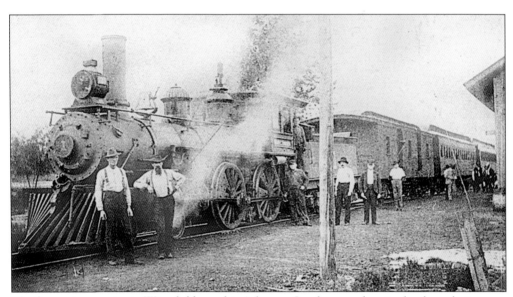

The first train to arrive in Winnfield was this Arkansas Southern work train that brought in crews to build a track. Crowds gathered, some camping overnight to await the arrival, but they stood at a respectful distance when it rolled into town June 21, 1901. Passenger service was a luxurious addition to life in Winn. At fore are Earvin (left) and Charles Sutton, brother and father of Clarissa Sutton, whose husband, Sheriff J.H. Crawford, helped bring the railroad to town.

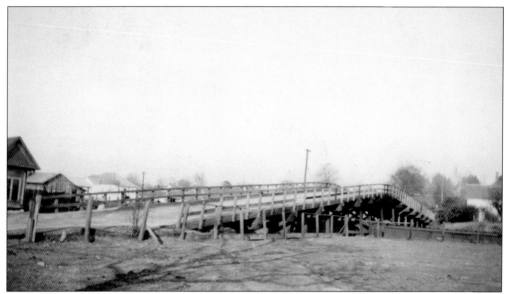

Local traffic on Highway 167 (East Lafayette Street) saw some relief from tie-ups at the Rock Island Railroad crossing with construction of a wooden overpass. Although it looks shaky by today's standards, it served its role until the late 1930s. (Courtesy Frances Walker.)

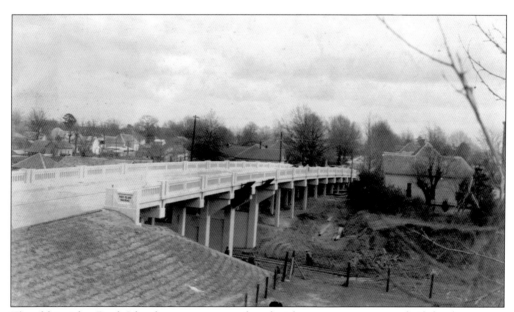

The old wooden Rock Island overpass was replaced with a concrete overpass built by the state at a cost of $60,000. The bridge was opened to traffic on February 17, 1938. This structure served traffic needs until around 2004, when four-lane Highway 167 was completed through town. (Courtesy Frances Walker.)

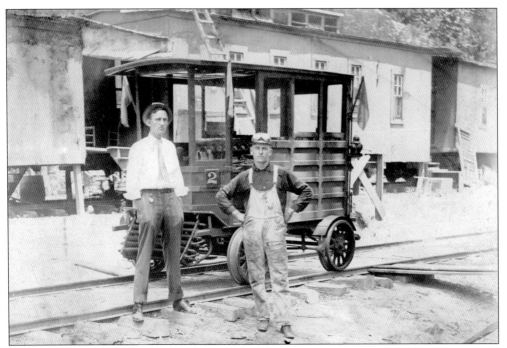

Frank Lancaster (right) was photographed in front of Winnfield's first motorized railcar, which he built. It proved quite handy in comparison to the other manpowered carts of the day. The "Limited" was used to run up and down the T&G rails for work on track repairs. Lancaster sent this picture as a postcard to friend Sam Lynch Jr. in Three Rivers, Michigan. (Courtesy Louisiana Political Museum.)

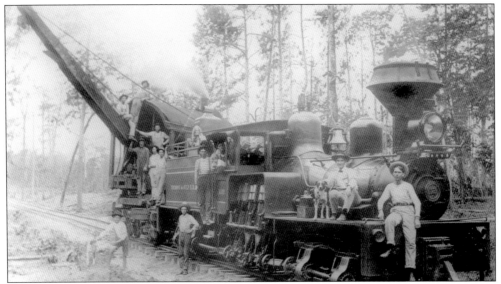

The prosperity of railroads and timber were intertwined at the turn of the century. Railroads realized the value of previously inaccessible timber and constructed lines into areas like Winn, which was eventually served by five separate railroads. Steam-powered skidders and loaders with 1,000-foot cables could help clear a quarter-mile swath through the forests. In this photograph, a Shay engine is used for loading and track maintenance. (Courtesy Louisiana Political Museum.)

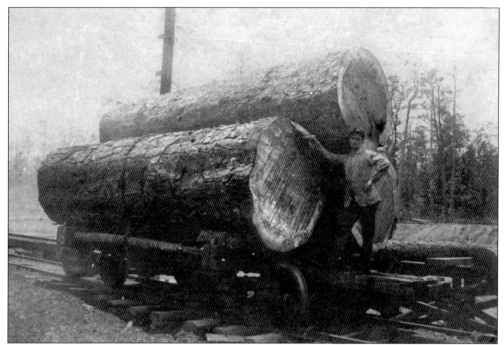

It's hard to visualize the size of the virgin pines cut in Winn Parish in the early 20th century. Three logs, likely cut from a single tree, load down a rail cart at Pyburn near one of the Tremont Lumber Company mills. Will Salton poses by the impressive load.

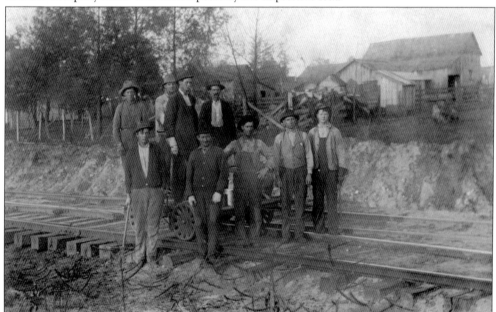

With rail transportation so vital to the early-20th-century economy, rail maintenance was critical to ensure the uninterrupted flow of goods and supplies to a community. To that end, section crews were responsible for the maintenance and upkeep of their assigned rail sections. Hours were long and hard and included replacement and repair of damaged tracks, crossties, bridge trestles, and switches.

The romance of rail transportation was at its peak when steam locomotives, powered first by wood and then by coal, hauled loads of freight or passengers down the line as smoke billowed from their engines' stacks. In this shot, Engine No. 20 of the T&G rounds the corner at the Rochelle Crossing.

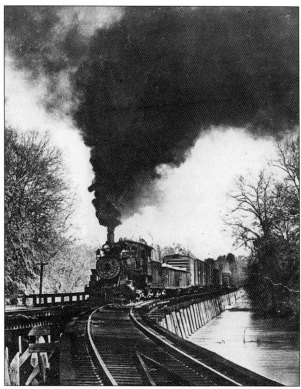

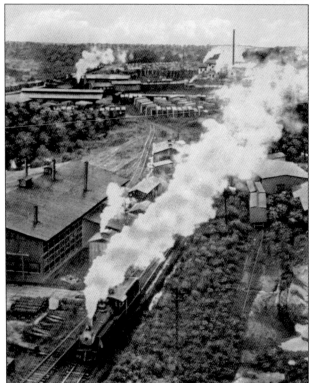

This high-angle photograph that looks west towards T.A. Ferrell's house illustrates the vital connection between lumber mills and rail transport. Trains run along two tracks, with the Mansfield Hardwood Lumber Company in the background and the T&G machine shop in the foreground. (Courtesy Greggory Davies.)

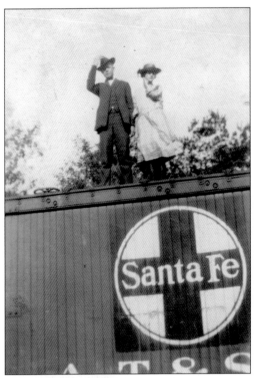

The T&G passed through Ringwood in the 1920s, at a time when people gathered pinesap for manufacture into turpentine. It was collected then much as maple syrup is gathered today, with a gash cut into the tree trunk and resin caught in a metal container. Drew and Vada Curry pose for a photograph atop a railcar. Judging by their attire, they were probably on a Sunday stroll. It would have been a three- or four-mile walk through the forest. (Courtesy Helen Maloy.)

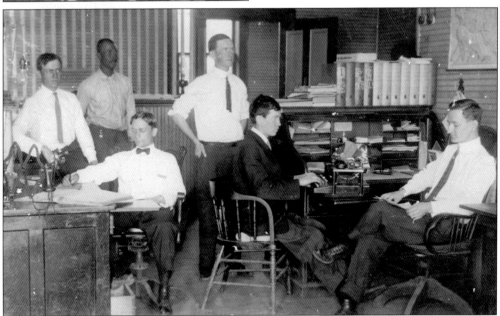

With rail as the primary means of transportation in the early part of the 20th century, moving merchandise, produce, mail, and passengers, the depot served as a hub of the city's economy, with spinoff services such as restaurants, hotels, and livery stables. This photograph inside the Louisiana and Arkansas (L&A) Depot, located on Highway 34 South, shows, from left to right, agent H.R. Whitting, clerk Carey Moore, operator H.D. Malley, chairman L. Rickerson, Aaron Harris Porter, and Luther Moore.

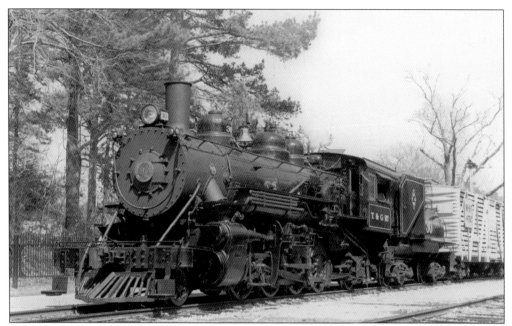

Residents who lived in Winnfield in the days of steam engines like T&G's engine No. 30 nostalgically recall the mournful sounds of their whistles as they approached town. Each engineer had his own telltale sound that he created with his whistles. The crew of "Old No. 30" included engineer Andrew Jenkins, car inspectors T.A. Ferrell Sr. and Jessie Boyett, conductor C.W. Crippen, brakeman Jack Vinning, and fireman Gentie McDaniels. (Courtesy Tremont Lumber Company.)

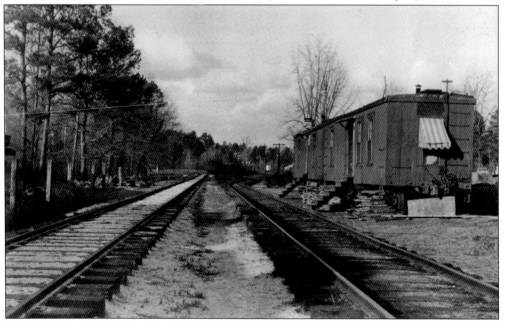

Worn-out wooden boxcars were used for temporary housing by railroad employees, whether maintenance or train crews. Only after the railroads had no more use for the cars could they be used for other purposes. Note that these were old wooden boxcars, identifiable by brake wheels on the roofline of the cars.

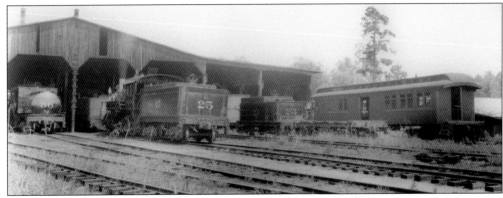

This is the locomotive house, the repair shop for T&G's trains. At left is the Vanderbilt tender, built in 1917, which supplied fuel oil for Engine No. 30. (Still in service, No. 30 was later sold to a mining company in Arizona as Engine No. 7, then to a historical train line in Rusk, Texas, as Engine No. 300.) (Courtesy Tremont Lumber Company.)

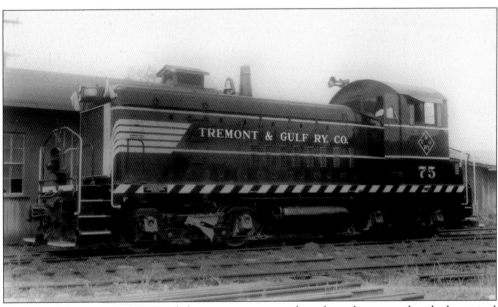

The day of the steam engines and the romance surrounding them disappeared with the arrival of the more efficient but less glamorous diesel engine. T&G's Engine No. 75 was one of the early model diesels, as can be seen by the single stack on top; later models would have two. The engine is still in operation today at an oil refinery in Texas. (Courtesy Tremont Lumber Company.)

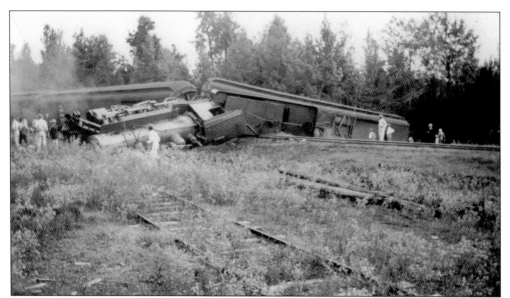

Despite the best efforts by section crews, train derailments and wrecks occurred frequently, since it took only one loose rail to cause a mishap. This wreck scene may be more common than famous, showing two abandoned tracks and a wreck on the main track involving all cars, including the locomotive and two passenger cars. (Courtesy Frances Walker.)

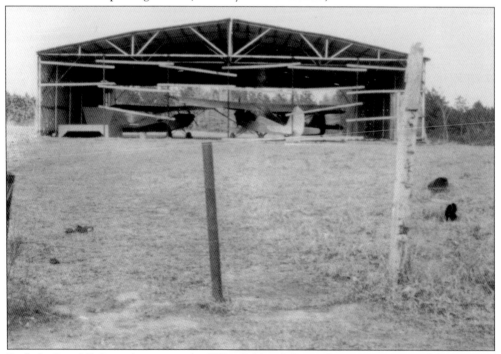

Both the David G. Joyce Airport north of Winnfield and the small community around the Tremont mill were named for the son of T&G railroad magnate and owner of Tremont Lumber Company. The airport was built in the early days of aviation, before there were many licensed pilots. After returning from World War II, Gordon Stewart became the first local flight instructor. The airport's grassy field is visible in this photograph from the 1940s. (Courtesy Emma Jo Carpenter.)

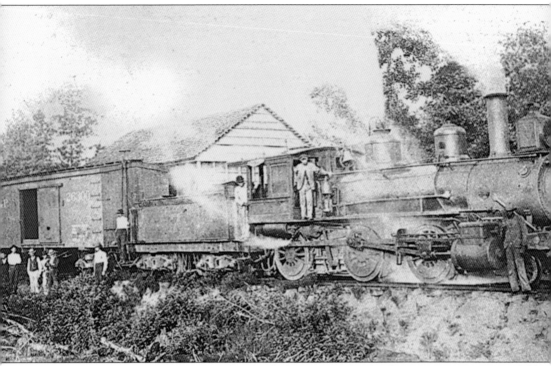

When the Arkansas Southern Railroad rolled into town for the first time in 1901, Winnfield residents knew life was going to change for the better. Historically, communities grew up around their primary transportation source. That source would initially be rivers and ports. With the arrival of railroads, the town's business center gravitated towards the rail heads. As industry and the economy expanded, so did rail service, and Winn would eventually be served by five lines. Those were Louisiana and Arkansas, Rock Island, T&G, Louisiana Midland, and Kansas City Southern. All provided passenger service as well as freight. The next population shift came with construction of efficient road systems and easy access to vehicles for families. In this postwar era, many businesses began a migration from the traditional downtown sites near rail lines to outlying highways and suburbs.

Three

Businesses through the Years

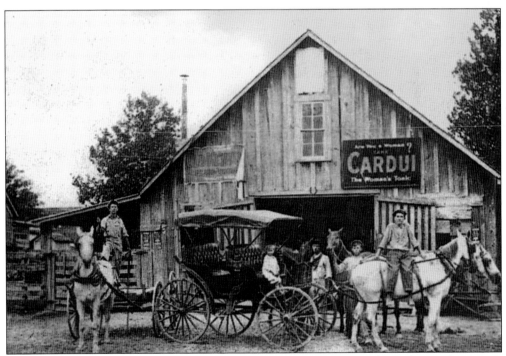

Cox's Mule Barn was an important business in early Winnfield. It was located near the current fire station, with Bass' Blacksmith Shop next door. Next was the icehouse where folks could bring their watermelons to be cooled. In its day, school girls could go down to the livery stable on Saturday mornings and pick out a horse, which the stable employees would then saddle and allow the young ladies to ride.

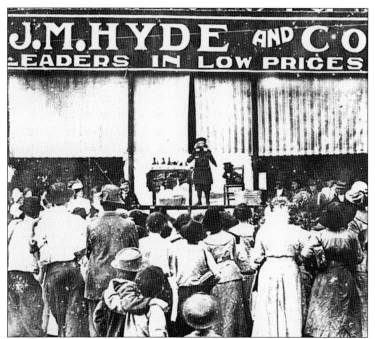

This early-20th-century photograph shows a crowd gathered at J.M. Hyde and Co., located at the corner of Main and Abel Streets, to watch a demonstration by an actor portraying Buster Brown and his dog, Tige. Pete's Grocery, Winn State Bank, then Pharmacy Services later occupied that site. Hyde's was a general merchandise store that even bought and sold cotton. A successful businessman, Hyde owned a number of downtown buildings.

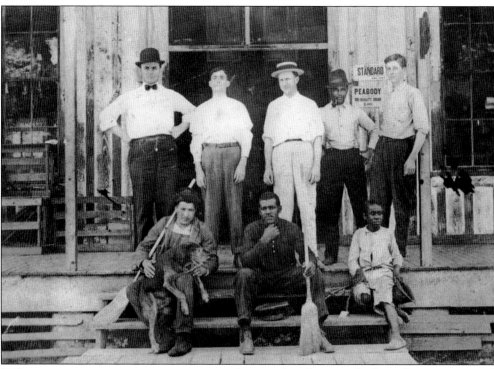

Before transportation was convenient, general stores played a central role in the economic and social life of small towns and were essential for mills throughout Winn. One such store was Avoyelles Cypress Co., about 2.5 miles past Atlanta off the Verda Highway. Meat market owner Gus Ferguson, standing to the far right, said he could have made a fortune selling soft drinks if only he had a way to keep them cold. (Courtesy Vara Smith.)

The Winnfield Drug Co. was owned by brothers Joe and John Emerson in the 1920s, prior to a split that saw Joe open his own pharmacy, Emerson's. John ran a successful business selling medicines, gifts, cosmetics, and magazines until his death in 1959, at which point his son James Hall Emerson was called back from active duty to run the family business. Juanita's Hairstyles for Women was located on the second floor. (Courtesy Jeri Emerson.)

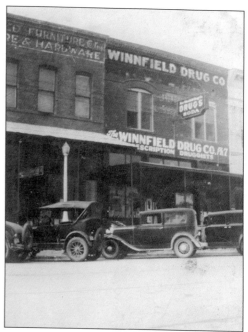

The city's oldest existing business, the Bank of Winnfield, was organized by Shreveport businessman S.W. Smith Jr. in 1901 for a horse and buggy–era Winnfield. Bookkeeping was done by hand in pen and ink, but local newspaper *Southern Sentinel* called it "one of the safest banks in Louisiana." This photograph shows the bank's second building (1904–1913) on the corner of Abel and Court Streets. (Courtesy Bank of Winnfield.)

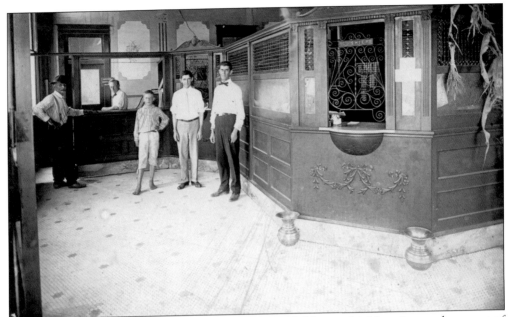

This scene reveals the ornate interior of Bank of Winnfield at its third location on the corner of Abel and Main Streets. Bank president B.W. Bailey, at the counter, waits on a customer. Standing by are, from left to right, Cyrus McGinty, J.R. Heard (vice president), and C. McGinty (cashier). The bank's initial capital stock was listed at $50,000 when it was located in a small building on East Main Street. Some 50 years later, assets exceeded $2.7 million. (Courtesy Bank of Winnfield.)

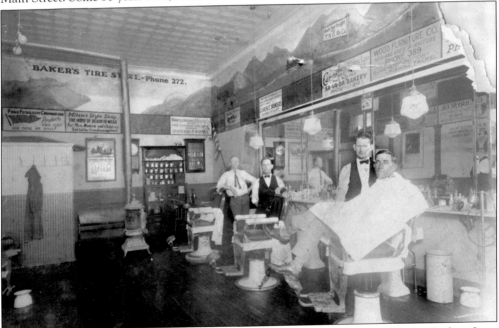

There were three chairs and no waiting at the City Barber Shop on Main Street. Barbers Jesse Shelton, Bob Smith, and Joe Terrel could take care of a haircut or shave. During this time, visiting the barbershop was a social event, and men could go there to learn the news of the town. A shoe-shine stand was in the adjacent alley. (Courtesy Louisiana Political Museum.)

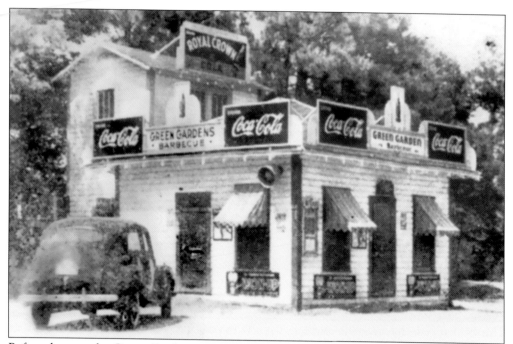

Before the war, the Green Garden restaurant was known as a "swinging place." Located at the intersection of Highways 84 and 167, behind the National Guard armory, it featured hamburgers, barbecue, and sodas. It was a popular teen hangout, but mostly for boys and men; ladies were reluctant to be seen there.

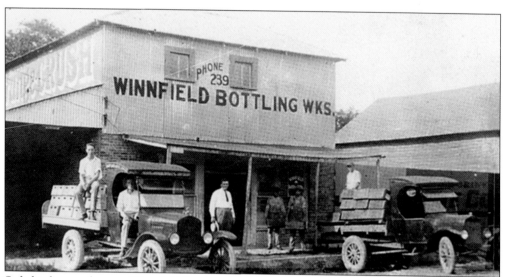

Soft drink manufacturer Winnfield Bottling Works is in this photograph from the 1920s. Located in a small building behind Harrell Cleaners off Main Street, it created (among other flavors) Orange Crush and Grapette. Locally made and then delivered to stores, it cost less than national sodas. Whether they came from an ice chest or iced down in a No. 2 washtub, these were refreshing summertime drinks.

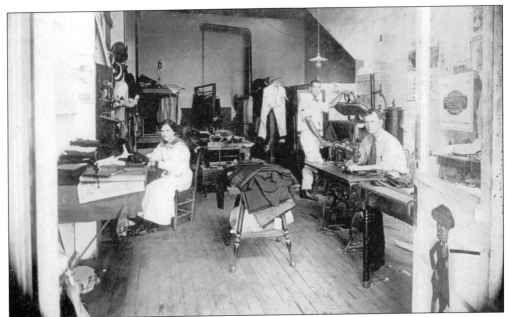

This 1930s photograph invites readers into Walker's Dry Cleaners on Main Street where the First Baptist Church gym is now located. Photographed at work are Mrs. W.J. Walker, "Sugar" Brown (at the press), and W.J. "Red" Walker (at the sewing machine, as they also did alterations). Before washing machines, housewives would wash everyday clothing in their backyards using large, black wash pots heated from underneath by fire. Notice the Buster Brown logo.

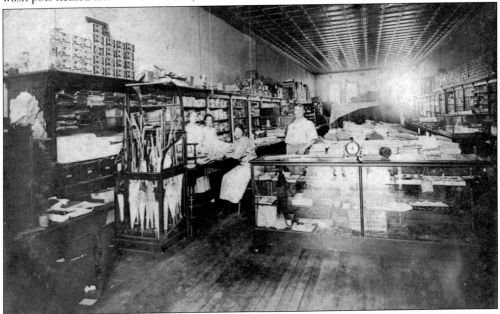

Family-owned stores like C.B. Cole Co. worked long hours to serve their customers. Never knowing when those customers might drop in, owners wanted to be there when buyers arrived. Cole sold shoes, hats, and clothing for men, women, and children. His sisters Janie and Eva worked for him, with Janie being a milliner who made hats for ladies in town. Chilled drinks were good to sell to passing soldiers during the maneuvers.

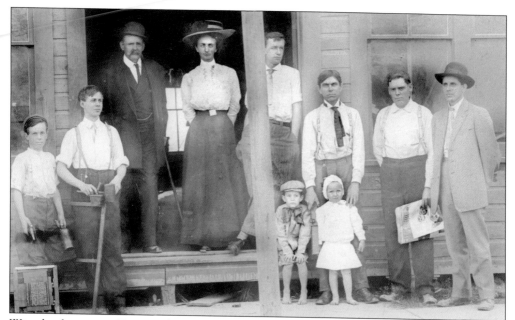

Winn has been served by a number of newspapers through the years, including the *Southern Sentinel*, *Excelsior*, *Guardian*, *Winnfield Times*, *Winnfield News-American*, *Comrade*, *Winn Parish Enterprise*, *Sgt. Dalton's Weekly*, and the *Dodson Times*. This picture from around 1910, taken in front of the Southern Sentinel building, includes two early newspapermen. *Sentinel* owner W.L. Smiley stands at left in the doorway. Henry Clay Riser of the *Enterprise* is second from the right.

The Womack General Merchandise Store in Sikes was bought from the Milams in the late 1930s. This family-owned store offered everything from groceries to shoes, chamber pots, ladder-back chairs, dishes, and horse collars and also contained "the biggest candy counter a child could imagine." Earl Long gave his last stump speech in front of the store in the late 1960s. "Abe" and Lona Womack pose with their son Karl in this photograph from the 1950s. (Courtesy Helen Maloy.)

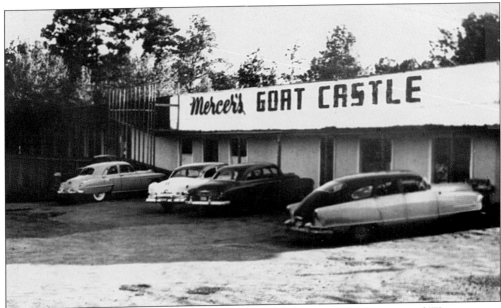

Readers have fond memories of various family-owned restaurants that have served Winn patrons through the years. The Goat Castle was owned by P. Hugh and Lois Mercer; Lois did the cooking, and daughters Anne and Doris Jean waited tables. With specialties like hamburgers, fried chicken, chocolate pie, and bread pudding, they had a big meeting room and a spillover crowd on Sundays.

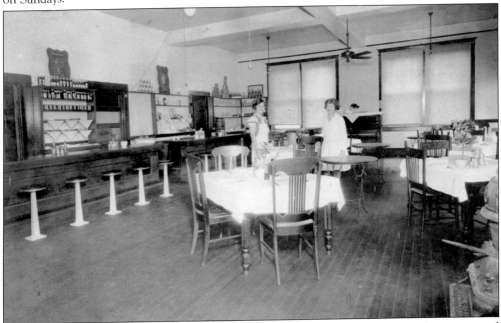

Different cafés attracted different clientele. The American Café, located on Main Street, opened in the 1930s and served as an old-fashioned café until the 1970s. Men who worked enjoyed the American Café, with its potbellied stove, marble counters, and home cooking, but the younger crowd tended towards nearby Minnie Breedlove's. The owners were Martha Dean and Blanchard Harper. (Courtesy Patsy James.)

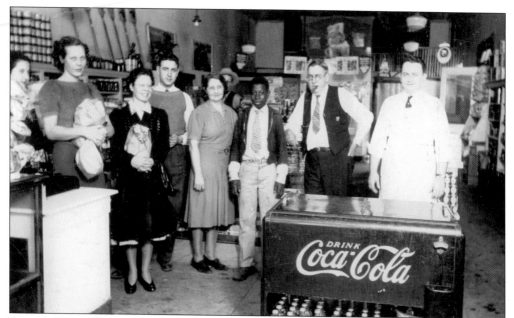

Winnfield was alive on Saturdays as people came to town from the country to shop, visit, eat, watch movies, and socialize. Stores like Pete's Grocery on Main Street accommodated by staying open until midnight. The mom-and-pop grocery charged their accounts, billing at the end of the month, and would deliver to their customers. "Pete" Peterson (cigar) poses with the staff, including his wife, Bessie (center), and their son Kelly (in a sweater vest).

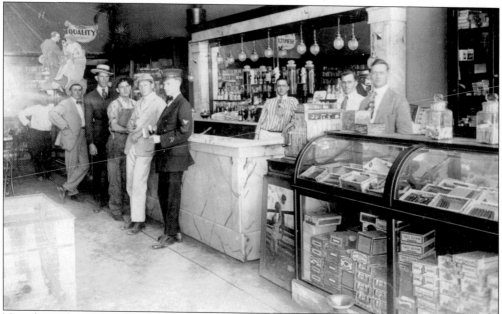

Nostalgic tales of downtown's past inevitably turn to Porter's Drugstore and his soda fountain. Staff and customers pose around the fountain at Porter's, home of its famous Cherry Nectar. The fountain served malts and milk shakes and had high-back booths in the middle of the store. Howard "Dick" Porter also sold comic books, and boys would come in to read them before going to Royal Ambassadors (RA) meetings at nearby First Baptist Church. (Courtesy Patsy James.)

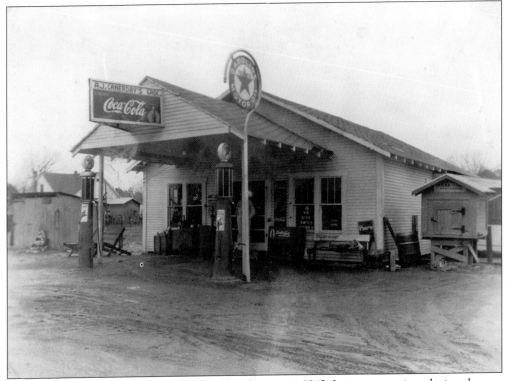

Charlie C. Canerday's Grocery was Calvin's only store in 1942. It was convenient during the war maneuvers, with an old icehouse for block ice and two hand-cranked gasoline pumps as well as kerosene. It carried canned goods and fresh eggs, and an old-time Planters Peanuts dispenser was on the counter for youngsters with extra change. Homemade clothes by Clarcy Canerday were also sold. (Courtesy Jeraline Shelton.)

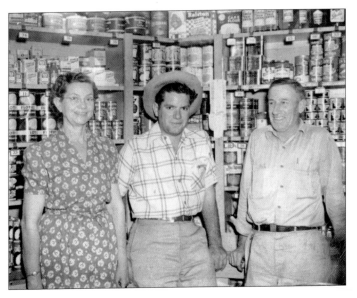

Owner Lena Willis (left), Puckett Willis (center), and Winston Hatten are at Willis General Mercantile in Sikes in this 1946 photograph. They opened in 1935 in a busy town; there were at least six other stores, two banks, two cafés, a motor company, a school, and many churches. The family-run store sold groceries, gasoline, feed, hardware, clothing, paint, guns, and ammunition. It was a community loss when it burned in 1957. (Courtesy Kelly Hatten Norris.)

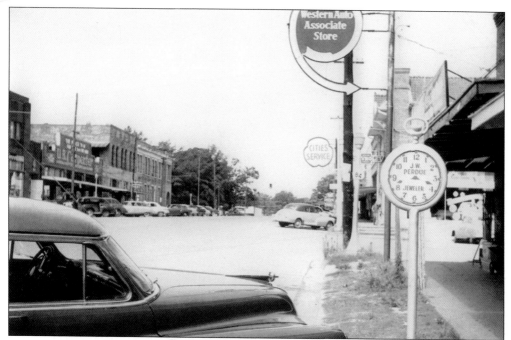

Before chain stores, malls, and online Internet purchasing, downtown was a thriving business area in Winnfield and in cities and towns across the country. This 1940s view looking up Main Street includes, on the left side of the street, Cora Sower's Dress Shop, U.B. Carpenter's, City Barbershop, Bank of Winnfield, and the courthouse. On the right side, the familiar J.W. Perdue Jeweler watch is a block farther east than it is today. Next door is Western Auto, then Max Theime Chevrolet. (Courtesy Phyllis Holmes.)

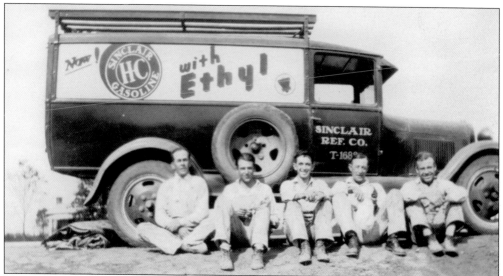

Senior motorists may recall when white-clad station attendants checked a customer's oil, air, and battery, then cleaned the windshield while filling the car with gasoline for pennies a gallon. John Robert Hall, left, and Willie Verne Hall, center, pose with the team in front of a traveling Sinclair truck that boasted the newest additive, ethyl, at Hall's service station on Court Street. (Courtesy Frances Walker.)

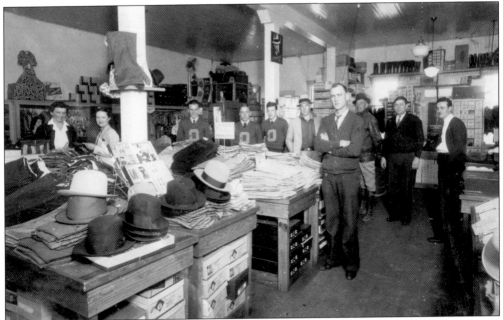

One local business success story was U.B. Carpenter, who began work with the Milams and went on to open a group of stores in Winnfield and around the region. The first, U.B. Carpenter's on Main Street near city hall, featured dry goods, clothing, and shoes for men, women, and children. As expansion space was needed, Winn Dry Goods on Court Street near Horton's Feeds followed, then Winn Department Store on Abel Street. In this photograph are, from the far right to left, Herman Bass, U.B. Carpenter, and Roy Carpenter. Doris Carpenter stands with her back to the pillar. (Courtesy Emma Jo Carpenter.)

Rural stores like Jim Bell's store and gas station in Atlanta not only provided fuel, convenience food, and supplies for the communities they served, they also gave locals a place to gather. Jim's son David, standing under the canopy, worked for Earl K. Long, serving as his bodyguard and driver. Seated in the shade are Maurie Ferguson (left) and Arthur Hattaway. (Courtesy Vara Smith.)

Four

Impact of Industries

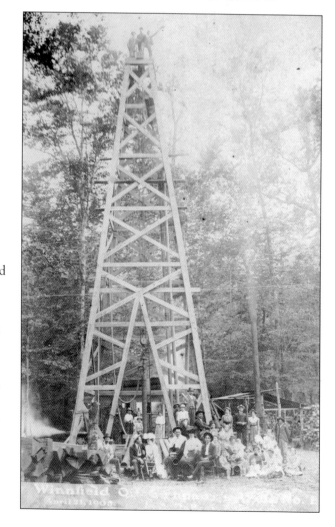

Before Edwin Drake struck oil and gained fame in Titusville, cousin Reuben Drake had developed the rotary drill and used timber casings to drill water wells as part of his operations at Drake Salt Works in western Winn Parish. The radical technology would open the door for the oil industry in petroleum-rich Louisiana. Winnfield Oil Co., using the L.B. Clifford oxen-powered rig with a hickory drill bit, dug the first wildcat well 1,011 feet deep on the Cedar Creek Salt Dome in 1903. The first producing well would come 23 years later.

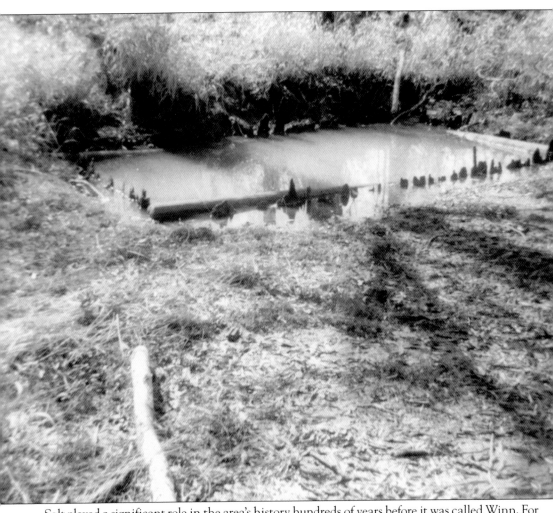

Salt played a significant role in the area's history hundreds of years before it was called Winn. For centuries, Indians followed trails for great distances to get to the saline springs in the area now known as Drake Salt Works. Spanish explorers would record the site as early as 1528. Postelwaite began to extract salt commercially from the area in 1795, but production was low, at around six bushels per day. Making the real investment in the venture was Burnett, who purchased Postelwaite's operation in 1818, providing a levee, aqueducts, an impressive series of salt kettles, furnaces, and copper tubing. Production grew to 30 or 40 bushels per day. Reuben Drake bought the venture in 1830 and drilled wells to support production. A town, Saline Mills, sprouted around the industry and grew impressively by 1850, with visitors coming to the salt springs for therapeutic bathing. Salt was vital to the economy, and in one Civil War skirmish, Union troops tried to disrupt this reliable source for the Confederacy. But Confederate forces met the Union detachment at Salsbury Bridge and defeated them. Mining and drilling operations following the war revealed vast sources of salt in shallow salt domes, and the old extraction process was rendered obsolete. A Monroe newspaper account from two decades after the war indicated that only a shadow remained of the former glory of the salt works. Little survives of the works other than its history.

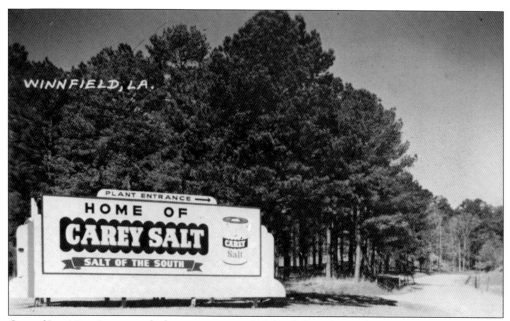

One of Louisiana's many salt domes is a scant 440 feet below the surface in Winn Parish. Carey Salt opened its local operation in 1931 and bolstered the local economy for about 35 years, until the mine flooded in November 1965. Rock salt was mined more efficiently than earlier evaporation methods. In this photograph is the sign at the entrance to the mine and plant site on Highway 84 West.

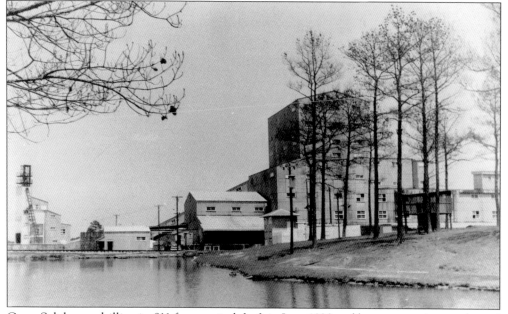

Carey Salt began drilling its 811-foot vertical shaft in June 1930 and began operations at the end of the following year. With about 100 employees and a $500,000 annual payroll, the mine was a major player in Winn's economy. The towering mine-shaft entrance (left) and the eight-story processing plant (right) where the majority of the employees worked can be seen in this photograph taken from across the mill's pond.

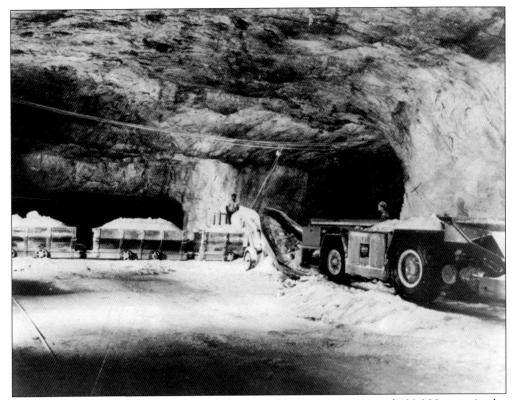

Annual production of salt at the Carey mine ranged between 100,000 and 120,000 tons. As the tunnels and rooms of the mine were enlarged, huge pillars of salt were maintained to support the ceiling, with no additional bracing required, as in this photograph. In the process, an "undercutter" would create a floor-level slot in the wall, eight feet in depth. Dynamite then broke the salt, which fell down into the slot instead of out into the chamber.

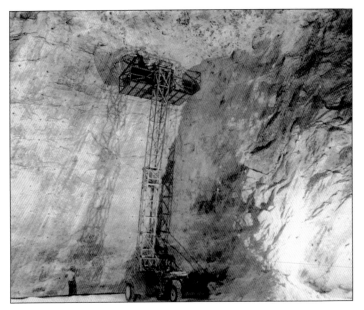

The salt deposit at the Carey mine's 811-foot depth was about 1,000 yards wide and 1,500 yards long. As tunnels and chambers within the mine were developed and enlarged, they could range from just 25 feet wide and 10 feet high to 60 feet wide and 90 feet high. Length might be 1,500 feet. One of the taller chambers is captured in this photograph. Had the mining operation continued, even larger salt deposits lay beneath.

Holes bored in the solid salt face of the mine's wall were used for dynamite that blasted the mineral free. Once the scene was clear, workers drove in equipment to load the loose material. It was then conveyed to the processing plant, where it was crushed and graded by size, then packed into individual bags. A 45,000-pound carload of cases could be processed in 30 minutes. (Courtesy Janee McDuff.)

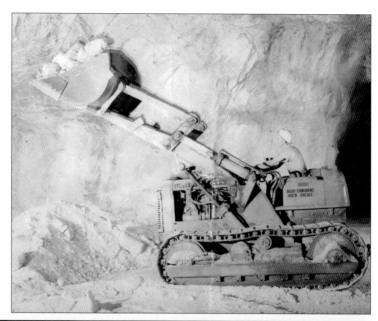

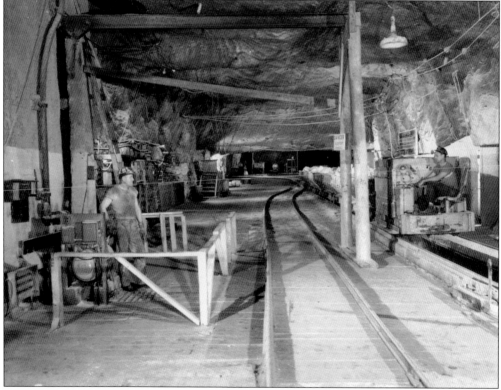

Approximately five miles of narrow-gauge railway were maintained within the Carey mine, with an electric engine and dump cars. Salt was loaded into those cars and run to the hopper at the shaft to be transported by chute into a huge bucket. The bucket hoisted its load to a crusher on the surface. A continuous roller belt then conveyed the salt to the mill building, where it was milled to specification, screened, graded, and packed. (Courtesy State Library of Louisiana.)

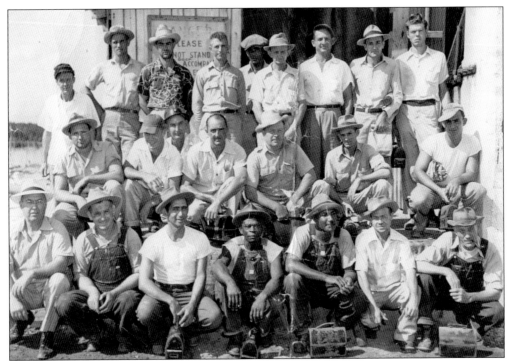

The Carey Salt mine lasted only a few decades. An apparent geological shift in 1965 caused spring waters to begin leaking through the mine walls, eventually flooding the entire mine. This was the second such leak in the mine's history, a smaller leak in 1937 having been repaired. Impact on the community, with job losses for employees like these, was considerable. (Courtesy Janee McDuff.)

Many of the employees at the Carey Salt plant were in support positions. This group includes, from left to right, (first row) general manager Jake Cameron, Al Tracy, Lois Davis, Barbara Smith, Margaret Straughan Tarver, and Annie Lee Bice Keaton; (second row) Jesse Thornton, Deb Simmons, Ruby Bowen, Jewel Maxey, H.W. Stinson, W.O. Rigdon, and Floyd Main. (Courtesy Louise Watts.)

Local legend holds that a farmer, discouraged with his rocky land west of Winnfield, swapped it for a mule after the Civil War. A short time later, an outcrop of gypsum was discovered, but the deposit quickly played out. Underneath was a vast deposit of anhydrite, a less-stable cousin to gypsum, lacking two water molecules. Mining of the product has created a huge quarry.

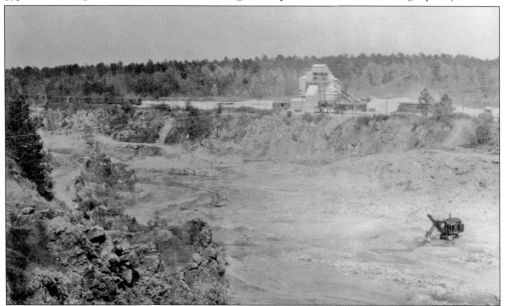

Anhydrite can be found as a cap rock for salt domes. This photograph of the Southern Mineral Corporation (later Winn Rock) quarry looks west towards the Carey salt mine operation. The mineral is not sufficiently stable for use in concrete, but when placed on roads for exposure to rain and traffic, it tends to "set up," thus becoming a good material for oil field roads. The quarry purports to be the "largest hole in Louisiana." (Courtesy Louise Watts.)

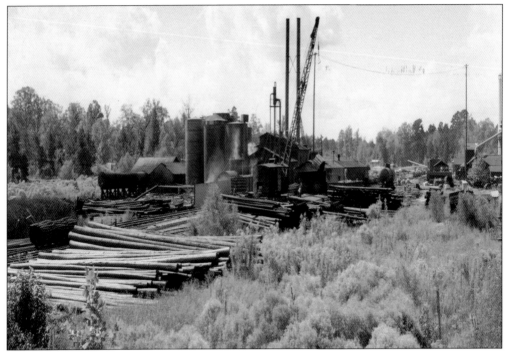

Apart from the manufacture of timber into dimensional lumber and plywood, little has been done to make value-added improvements to Winn's vast forestry resources. One exception was the American Creosote Works on the south edge of town. It operated for nearly three-quarters of a century using a coal-tar creosote solution as a wood preservative to make telephone poles out of long, straight timbers. (Courtesy Louisiana State Library.)

In Winn's early days, there were not many large farm operations. Families had to be more self-sufficient, keeping small gardens, cattle, and dairy cows. Some also grew small cash crops, particularly tomatoes. Many grew a small patch of cotton, mostly for sale but some for home use. A small oat thrashing operation is pictured. (Courtesy Janee McDuff.)

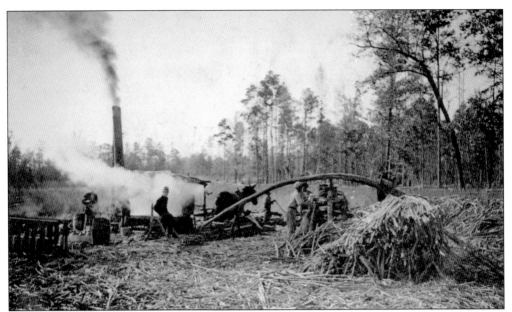

In the old days, families made their own cane syrup or bought it from their neighbor. Every fall of the year, after harvest, it was time to make syrup. Stripped cane stalks were handfed into a grinder to extract the sweet cane juice, with the operation being powered by a mule. The juice was then cooked and evaporated to render the sweet final product. (Courtesy Paul Peters.)

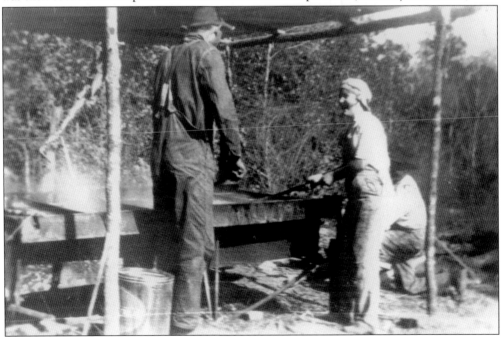

This 1930s photograph shows the syrup-making process on Buckskin Road. Cane juice is cooked in a series of shallow pans over a fire and stirred and skimmed constantly in an all-day operation to create the distinctive taste of thick, sweet, rich cane syrup. Traditionally, making syrup is not just a job—it's a social event. In this photograph are, from left to right, Wiley Abrams, Bertie Curry, and Thomas Jefferson Curry. (Courtesy Helen Maloy.)

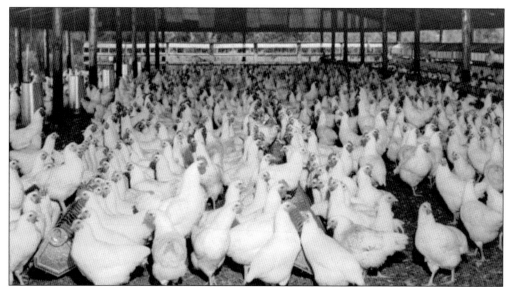

John Jordan began his egg farm in the Hudson community in the early 1940s, and the business continues to thrive. Using White Rock hens for reliable production, Jordan and his family have been delivering eggs to retail stores and institutions throughout Winn and surrounding areas ever since. Local customers have come to rely on the quality of this hometown product. (Courtesy Louisiana State Library.)

Michael Adam Gaar built a one-horse gristmill in 1857 in a community 15 miles north of Winnfield that became known as Gaar's Mill. A steam-powered mill and cotton gin followed in 1872 as the community grew around it. While timber was Winn's primary agricultural product, enough cotton was grown in the area to warrant the gin's continued operation for nearly a century. It was the last diesel-powered gin in north Louisiana. Shelby Gaar stands in the doorway. (Courtesy Gaar family.)

Five

PEOPLE OF OUR PARISH

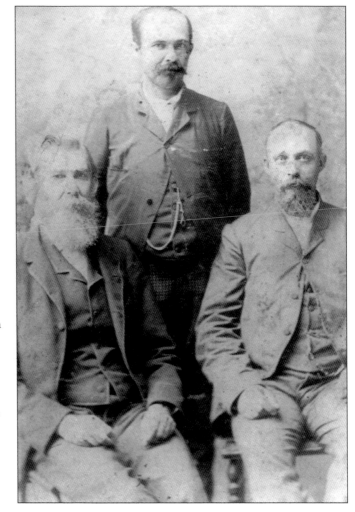

Many folks have framed photographs in their attics of unidentified people assumed to be ancestors. However, some do include names. Three elected Winn Parish officials of the 1880s were photographed in a traditional pose of the era. Seated on the left is Judge Bob Jones. Seated at right is District Attorney John T. Wallace. Standing is John Egbert DeLoach, who was appointed Winn parish sheriff by Gov. Francis Nichols on June 23, 1888. (Courtesy Missy Smith.)

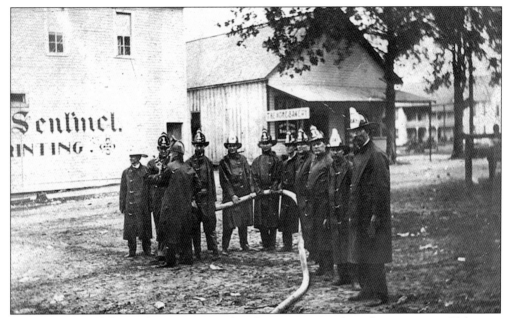

In early Winnfield days, volunteer citizens played an important role in the community. Volunteer firemen, in their protective helmets and heavy coats, hold a training exercise against the side of the Southern Sentinel newspaper building on the dirt streets of downtown Winnfield. In background is the Home Bakery. (Courtesy Ed Grigsby Collection.)

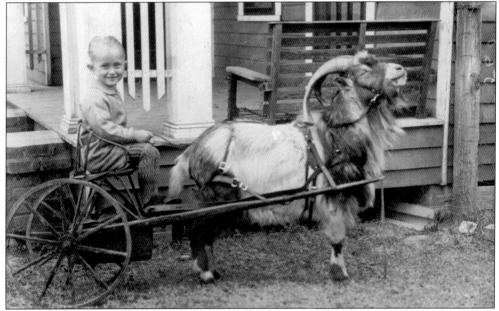

Before good roads and reliable vehicles were commonplace, traveling salesmen brought their wares and services to the doors of their customers. A homemaker could get fresh produce, shoes, clothing, and more, while services included pot repairs and even feather-mattress refurbishing. Cameras and developing were scarce, so traveling photographers came to capture images of families or children on ponies or dogcarts. In this case, J.T. Jennings is photographed on his goat cart in the late 1920s. (Courtesy Helen Maloy.)

In 1937, N.M. Jackson was a familiar site as he took his horse-drawn wagon to deliver bottled milk to his customers around Winnfield. Cars were available, but Jackson preferred his reliable horse, Jim. He operated a small dairy farm and walked his cows down the street to pasture. The businessman raised a family of six but still found time to milk the cows, bottle the milk, and deliver seven days a week. (Courtesy Sara Shell.)

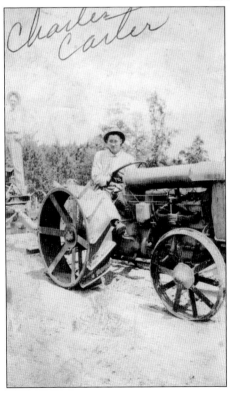

During its first century, Winn witnessed farming technology transition from manpower to animal power and then on to tractor power. In this photograph, Charles Carter sits proudly on one of the earlier tractors, with heavy construction and all-metal wheels.

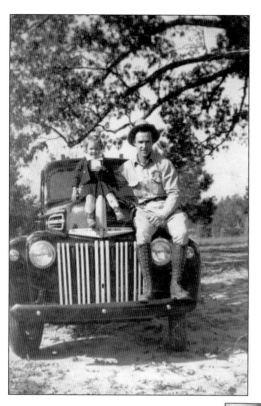

J.K. "Kermit" Martin balances his daughter Mary Alice Martin (McBride) in this photograph from 1940. Two years later, Martin would begin his logging career in Winn Parish as JKM Pulpwood, which is now operated by his son John Kelley Martin. The elder Martin in later years expanded his involvement in the forestry industry as co-owner of Winnfield Hardwood and Martin Forest Products.

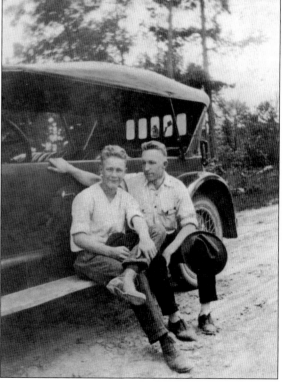

Shirley Jackson (left) and W.M. Matthews sit on the running board of a 1930s vehicle. Jackson was one of Winnfield's prominent pharmacists, working in drugstores in high school and then at Phoenix Drug in 1925 after receiving his degree. He opened his own business, Shirley's Pharmacy, in 1950 and a second one near the hospital in later years. He retired in 1970.

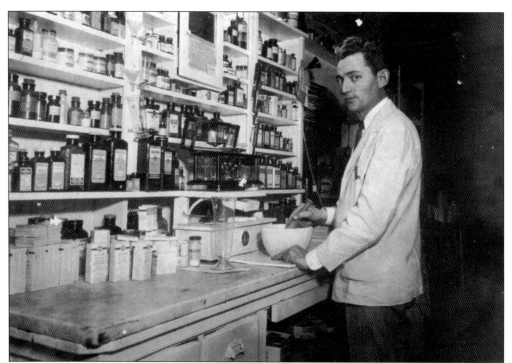

Iconic downtown business Winnfield Drugstore (the "New" was added to the name later) was always in the same location across Main Street from the courthouse. The business was opened by John S. Emerson, shown at the pharmacy counter. It boasted a soda fountain until renovations in 1965 and included a gift line and cosmetics. Brother Joe came into the business and then opened his own store in 1952. James Hall Emerson returned from service to run the store after his father John's death in 1959. (Courtesy Jeri Emerson.)

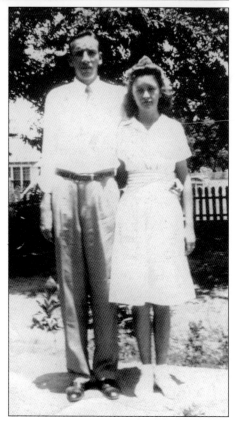

Sikes High School senior Geraldine Abrams stands with schoolmate James Womack in the spring of 1943. They would marry in the fall of that year, before his deployment to Europe with the 63rd Infantry "Blood and Fire" Division in Germany and France. When a landmine exploded in his face, Womack lost his vision and arms. A lengthy rehabilitation followed. The young veteran refused to rely on government support, and after unsuccessful attempts with door-to-door sales, dairy farming, and beef cattle, Womack put himself through college. He finished third in the Louisiana State University (LSU) law class of 1955, hung out his shingle in Winnfield, and practiced law until his death in 1990.

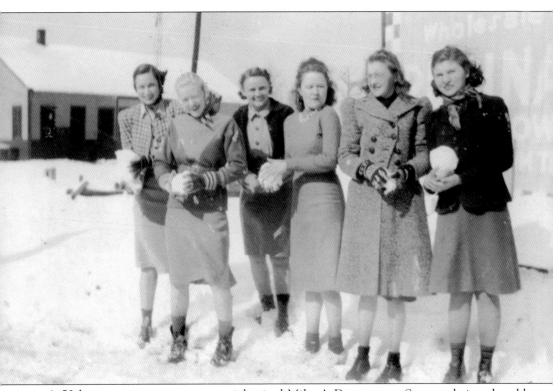

A 50th-anniversary newspaper article cited Milam's Department Store as being the oldest mercantile firm in Winnfield. Opened in 1906 by Matt Milam Sr. and his father, W.M. Milam, in a small frame building with a $1,000 three-year loan, the grocery business later expanded to dry goods. Brick buildings followed. The business survived the Depression and grew to include 10 stores, including a wholesale store, farm supplies, a Ben Franklin store, and a home furnishings business in Winnfield. There were also operations in Tullos, Jena, Natchitoches, Jonesboro, and Montgomery. Milam credited part of its success to dedicated employees like these young ladies, who have fashioned snowballs outside of the old Milam's warehouse on Main Street. The employees are, from left to right, Vara Ferguson Smith, Nelwyn Dennis Madden, Inez Keaton, Hazel Thomas, Ruth Russell, and Anna Bell Rudd Taylor. (Courtesy Vara Smith.)

As it does today, the city of Winnfield owned its utilities in years past, as witnessed by this 1938 photograph of the city's uniformed utility crew by the substation. They were charged with maintaining a reliable flow of electric power to the city's utility customers. Included in this photograph are, from left to right, W.H. Jordan, Jimmie Jenkins, Earl Honeycutt, Charlie Richie, and foreman Lawrence Donohue Sr. (Courtesy Neva Erskins.)

The convenience of refrigeration in postwar America has created a generation or two with no knowledge of the old icehouse trade. Families and businesses had iceboxes, and the ice company came around daily to deliver block ice. In this photograph, servicemen pose with the fleet of delivery trucks at the ice company's South Bevill Street location, opposite the city power plant, after the day's run. (Courtesy Neva Erskins.)

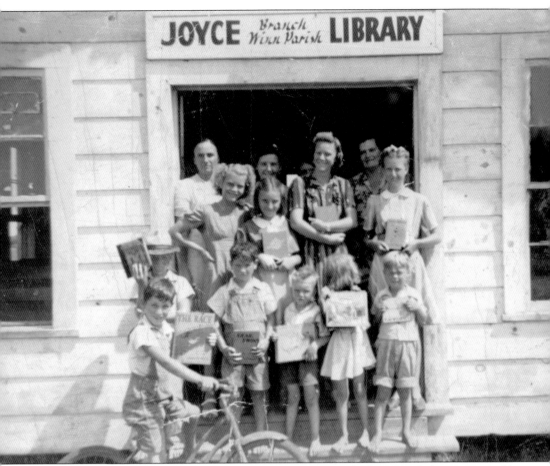

The Winn Parish Library had its beginnings in 1937 as part of a three-parish demonstration library, the first in the state and country. Opened in the old Bank of Winnfield building, it moved to its present Main Street site after Annabel Bozeman (the widow of Winn historian Harley Bozeman) donated the property and a building was relocated from Camp Livingston. A bookmobile served the rural regions of the parish, and in 1940, parish voters supported the system with a tax. In old Joyce, volunteers built a community house that was to become their branch library when people donated books. Bertha Wilkerson became the first librarian around 1938.

Agriculture played an important part in the economy of Winn Parish in its first century. Especially during the war years, agriculture teachers taught students the importance of gardens to enhance family diet. They also taught other cash crops and animal husbandry. Held in high regard, these teachers taught boys skills like plumbing, carpentry, and electrical skills that the man of the house—then in military duty—would have done traditionally. Shown is Atlanta's agriculture teacher, Darrell Allen. (Courtesy Vara Smith.)

The board of deacons plays a vital role in the Baptist church, and Winn Parish has its share of Baptist churches. In this photograph is a group of deacons at First Baptist Church in Winnfield. The deacons are, from left to right, (front row) Pastor H.H. McBride, R.H. Fletcher, Eugene Beck, and W.L. "Buck" Sowers; (second row) B.L. Anderson, J.B. Etheridge, Tom McKinney, John Sowers, W.D. Walker, S.S. Garrett, Jewel Maxey, and W.F. Minon.

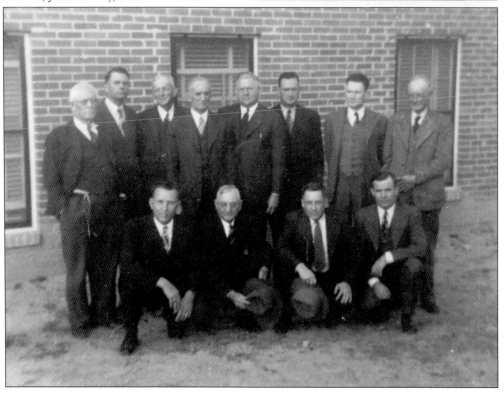

In Winn's early years, most residents had to be self-sufficient. Money simply wasn't available for purchases. James Monroe Moore of the Yankee Springs community was an excellent example of this. He built his log home with a tin roof and logs from his son-in-law's jake-leg sawmill. The chimney was made from mud and hair. In this home, he raised 10 children, nine to adulthood. The farmer grew cotton and gardens and kept dairy cows, hogs, and chickens. For the game he killed, he had a smokehouse to preserve the meat. On hog-killing days, lard was saved for cooking as well as for making soap. The only products that they bought were salt, sugar, flour, and coffee. They got their vanilla from the Watkins peddler. (Courtesy Kathy Guin.)

The old-fashioned general store in rural communities provided one-stop service for gas and groceries. At Canerday's General Store in Calvin, customers could get a handful of peanuts for a penny, an ice-cream cone for a nickel, fresh produce in season, cane syrup produced nearby, gloves, socks, and hats. Charlie, shown with brother William, featured a daily special to boost sales. (Courtesy Jeraline Shelton.)

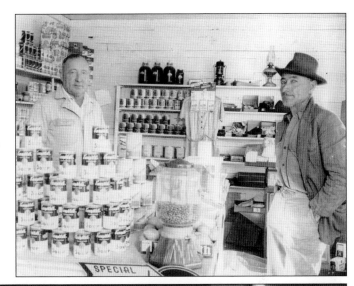

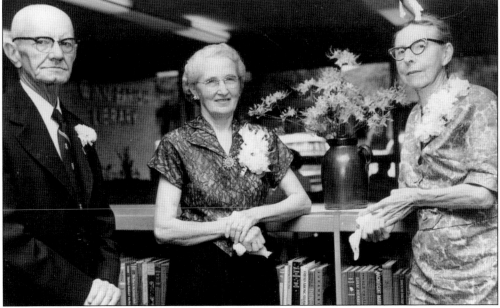

Several individuals who played a role in Winn during the mid-century pose in this photograph at the Winn Parish Library. On the left is Harley Bozeman, a classmate and best friend of Huey Long. Both became traveling salesmen after high school. Bozeman's mother, a teacher, planted the idea of free textbooks as a campaign strategy for Huey. When Long was elected governor, Harley went along and wrote most of the bills that the Kingfish would present to the legislature. They parted ways, and Harley went on to become a noted Winn historian with his own column, "Winn Parish as I Have Known It." Standing in the center is Ruth Cross Palmer. She was an author of historical novels, including *Golden Cocoon* (1924), for which she won the Pulitzer Prize in Literature. On the right is nationally acclaimed naturalist Caroline Dorman. She drew, in detail, natural plants, flowers, and herbs that grew in the wild, much like Audubon did with birds. She fought to win the name Kisatchie for the national forest. Her legacy includes the reserve around her home, just north of Winn, which is still open to scholars. She lived in a kerosene-lit log cabin until her death. (Courtesy Peggy Bozeman.)

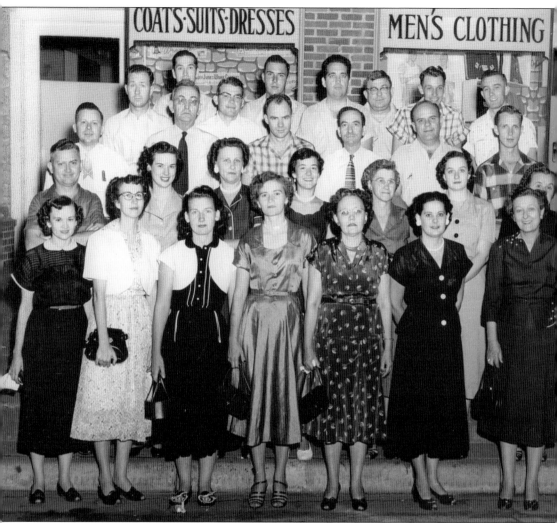

When the U.B. Carpenter Department Store opened on February 23, 1935, on Main Street in Winnfield, it would be the first of what grew to be a string of different stores in Winnfield and across north-central Louisiana. This photograph was taken at the Main Street location during an early 1940s gathering of employees from seven U.B. Carpenter stores. (Courtesy Emma Jo Carpenter.)

Six

ASPECTS OF
ARCHITECTURE

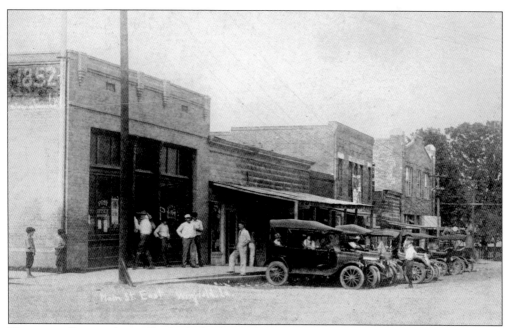

The post office, traditionally the hub of a small-town business district, is shown in this early photograph of downtown Winnfield. Mr. Robertson (in the white hat) ran the taxi service. The boy at the curb is Charlie "Toby" Gunn. The Western Union boy's name is Jolly.

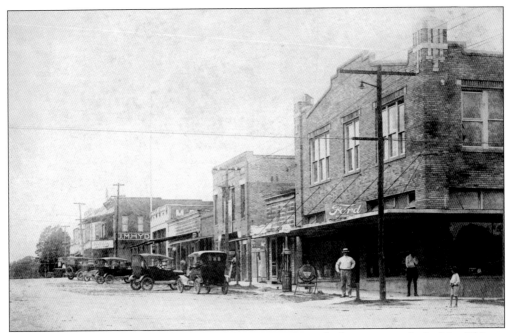

Another early view of downtown Winnfield shows Main Street looking west, with the Max Thieme Chevrolet building in the foreground. At this one-stop business, local motorists could have all their driving needs met. Thieme had an automobile showroom on the first floor, an elevator that lifted cars to the second-floor repair shop, and gasoline out front (note the pump by street). The man in army pants is Jesse Boyett.

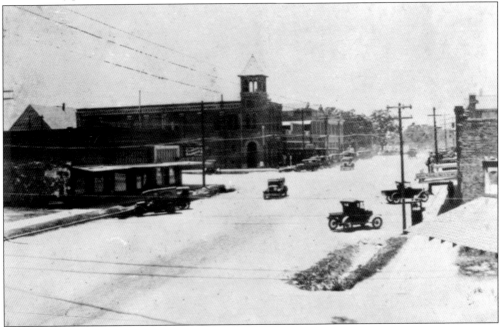

In 1917, the city of Winnfield still had wide dirt streets. Prominent in the foreground is the Winnfield City Hall, still with its original bell tower that was destroyed in the 1935 cyclone. Early-day vehicles touring on Main Street add a vintage touch to the classic photograph.

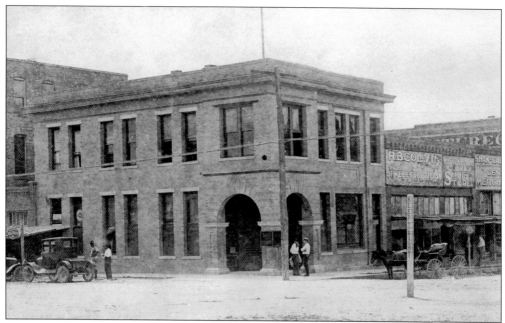

The Bank of Winnfield was photographed in its third location at the intersection of Main and Abel Streets in 1913. It was recognized by Louisiana as a sound commercial bank with the most modern bookkeeping equipment. The front of the second floor of the building would later serve as the first law office of Huey Long. A horse and buggy and an auto share the scene.

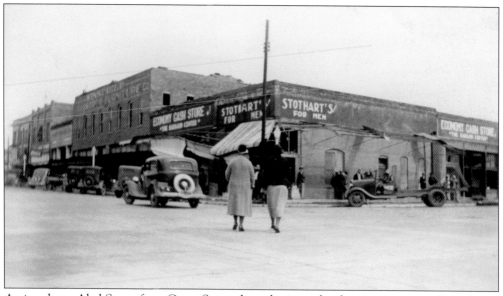

A view down Abel Street from Court Street shows business developments opposite Courthouse Square. Shoppers walk towards a popular menswear store (later to house Shirley's Pharmacy). Next to Economy Cash Store is Heard's Hardware, which carried everything from nails to coffins. Next is a drugstore, with the Fitz & Faith Clinic overhead. Another department store and the Bank of Winnfield finish out the block. (Courtesy Frances Walker.)

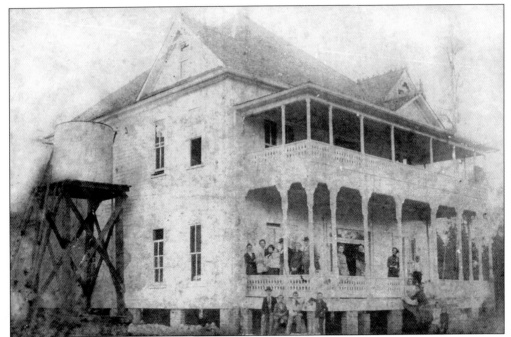

Winnfield was the showplace of a large number of early grand homes, such as this Victorian showpiece in Laurel Heights, photographed in the late 1880s. The Wallace Home served as a local boardinghouse, a practice common in that era. Note the columns and wide, banistered porches and the large tank to collect rainwater from the roof for household use. (Courtesy Greggory Davies.)

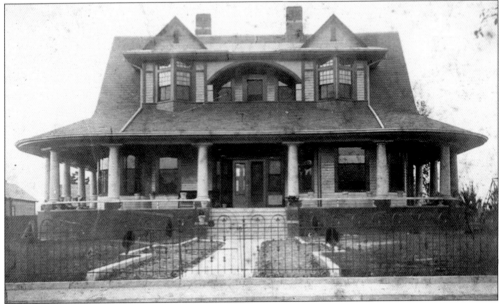

The G.P. Long House on Maple Street is on the National Register of Historic Places. This c. 1905 Queen Anne Revival is recognized for its historical and architectural significance. The lot was carved from a 160-acre tract that Huey P. Long Sr. had purchased for $1,100. George Long and his wife, Virginia, purchased the lot and raised seven children in the beautiful home.

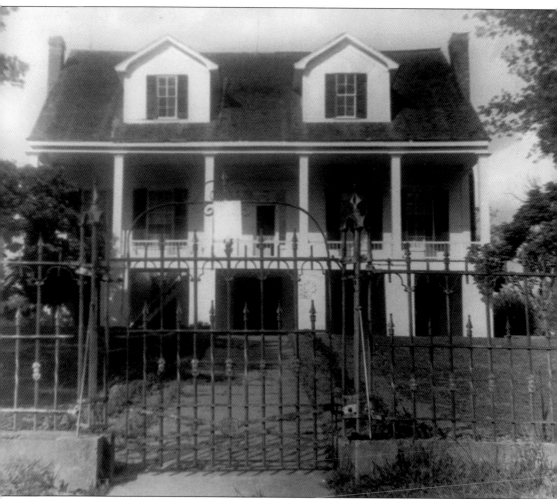

The Prothro Mansion was built for a wealthy South Carolina plantation family. It was constructed by slaves in 1826 on a high bluff over the Red River in St. Maurice and was located just west of the intersection of the Harrisonburg Road section of El Camino Real and the Natchitoches-Monroe Military Highway. With its location, it became a favorite stopover for important visitors before they crossed the Red River by ferry to Natchitoches. That guest list included Zachary Taylor, Robert E. Lee, Ulysses S. Grant, Jefferson Davis, Davy Crockett, Jim Bowie, and Sam Houston. The home was originally within Natchitoches Parish and was one of the most glamorous homes within the Natchitoches historic area. After an 1852 legislative act took this portion of Natchitoches into Winn Parish, tragedies befell the owners of the old mansion. Yellow fever brought the death of several Prothro family members and many of their slaves. In the post–Civil War Reconstruction days, carpetbagger boss Dr. David Boult acquired the mansion and much of its lands and held them until he fled to California in 1876. Although members of the Prothro family reacquired the mansion for a time, it soon passed into the hands of a succession of owners. Abandoned for a time, the old home went through some renovations in the 1970s but was destroyed by fire in 1982.

William Edward Burnum (left) and Allen Walker stand on the iron bridge at Walker's Crossing over the Dugdemona River. The brothers-in-law worked as part of the crew that completed the bridge in 1908. The bridge served the area until 1924, when it was closed. (Courtesy Joyce Walker.)

Willis Sholars (first cousin to Sheriff Bryant Sholars) and family pose by their beautifully kept rural home. Big porches, typical for this style of architecture, were wonderfully cool places for families to gather. The narrow-slatted fence kept debris out of the neat yard. (Courtesy Janee McDuff.)

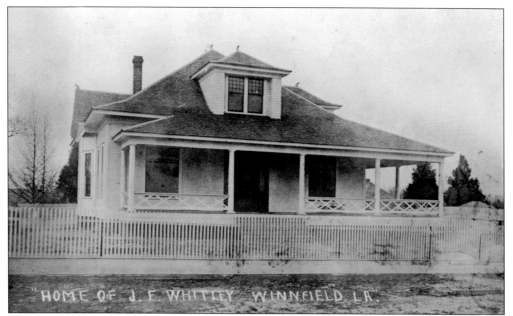

"HOME OF J. F. WHITLEY WINNFIELD, LA."

The home of J.F. Whitley in Winnfield is typical of the many turn-of-the-century homes that stood in the town then. The dormer on the roof is evidence of a second floor with a guest room (or children's room). Picket fences were popular, as they helped define the property lines, stretching to all corners of the lot. (Courtesy Paul Peters.)

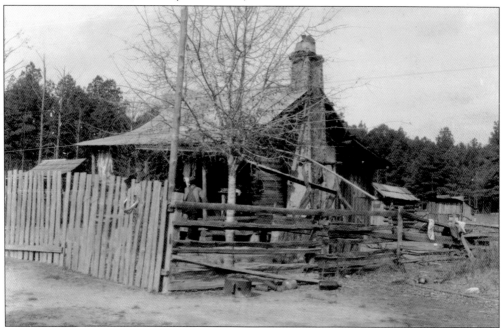

Beginning in the late 1800s, the US Forest Service engaged in a program of setting aside special-use land that allowed families to build their own log cabin on a designated segment, with the stipulation that they take care of the property until their death. Typically included with the house was a fenced yard and garden. This photograph of the Olvan Hollingsworth home was taken in 1938. (Courtesy US Forest Service.)

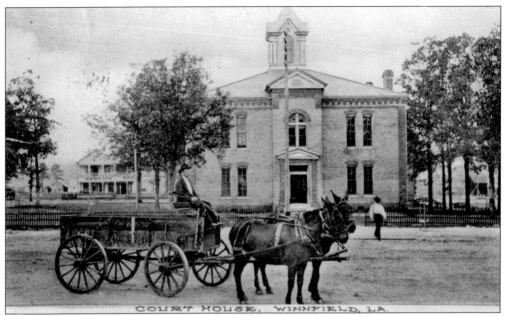

The first brick courthouse for Winn Parish was built in 1892 on the site of the present courthouse. The two-story frame courthouse previously on the site, along with all its records, had been destroyed by fire in 1886. This historic brick structure suffered the same fate in 1917, but this time, most of the public records were saved. Several other frame courthouses at other sites predated these. (Courtesy Greggory Davies.)

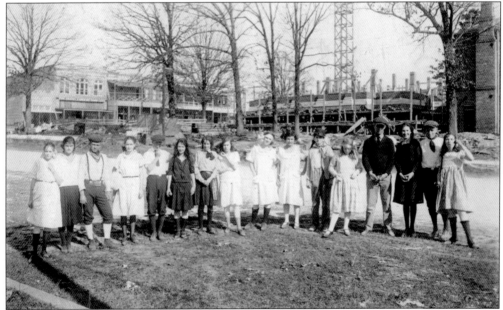

The beautiful "old" courthouse that old timers remember fondly was built in 1922 to replace its predecessor, which was destroyed a half-decade earlier. In this photograph, the Winn High School (WHS) graduation class of 1922 stands in front of the construction scene on Tramp Day. At least one of the earlier courthouses was torched in 1869, purportedly by the West-Kimbrell Clan, to destroy incriminating records.

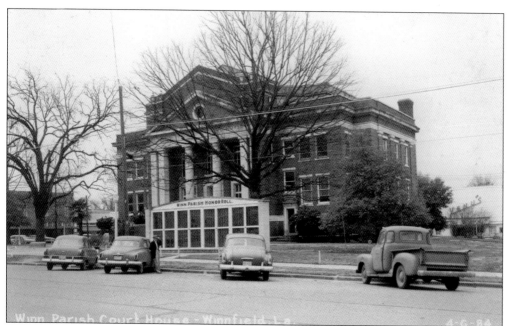

It took two years to construct the "old" courthouse on the square, and it was the centerpiece of downtown Winnfield. It served the community from 1922 for nearly four decades before it was torn down and replaced by the current building, which opened in 1962. Standing in front of the courthouse is the honor roll for Winn veterans. The bandstand and Confederate Memorial stood on the Abel Street side. (Courtesy Greggory Davies.)

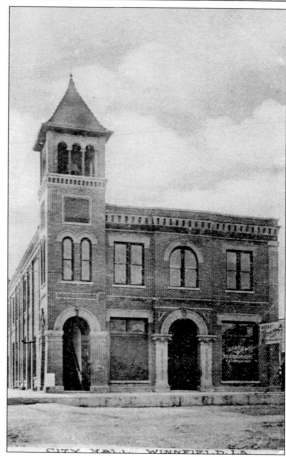

Standing proudly on the corner of Main and Beville Streets since 1907, Winnfield's city hall originally boasted an attractive brick bell tower. The tower was lost in the cyclone of 1935 and only later replaced with a replica. City hall at one time also housed the fire station on the Beville Street side. The second floor was the setting for city court; in the earliest days, it housed the opera house and a boxing ring. (Courtesy Greggory Davies.)

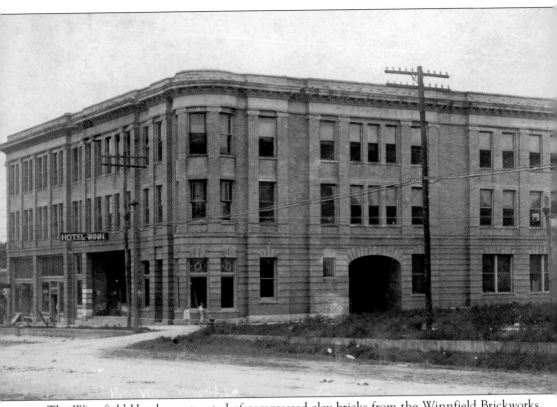

The Winnfield Hotel, constructed of compressed clay bricks from the Winnfield Brickworks, began receiving guests in February 1908. The three-story Main Street hotel had an attractive appearance, with a beautiful stone finish and broad, high, plate-glass windows. The ground floor boasted a spacious lobby, an office, a baggage room, a reading room, a barbershop, and a dining room where elegant meals were served. The second floor included 30 bedrooms (20 with private baths) plus an alcove parlor with wicker chairs and piano. The third floor was similar. Street-access shops included the Western Union office. During the military maneuvers in 1941, Gen. George Patton, Gen. Dwight Eisenhower, and Gen. George Marshall were among the brass who stayed there. Local lore holds that World War II was fought on napkins at the Winnfield Hotel. Other notable guests included First Lady Lou Henry Hoover and gangsters Bonnie Parker and Clyde Barrow. It was the first Winnfield landmark to be listed on the prestigious National Register of Historic Places. The historic old building was torn down in early 1997.

Seven

WINN *IS* POLITICS

The seeds of Winn's political culture may have been sown in the heavy toll of the Civil War and the resentment of the years that followed. They were manifest in the Farmer's Union and later the Grange Movement of the 1870s and the Populist Movement of the 1880s and 1890s, all of which were embraced by area residents. During traditional political "stumpings," folks flocked to Courthouse Square to hear impassioned speakers.

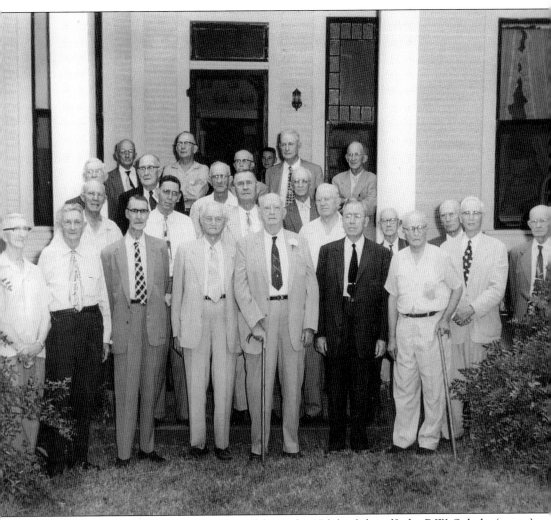

Winn's community leaders gathered to celebrate the 85th birthday of Judge R.W. Oglesby (center). Included in this photograph are, from left to right, (first row) B.W. Bradford, Arnett Garris, P.K. Abel, W.T. Norman, Judge Oglesby, Cas Moss, B.W. Bailey, A. Leonard Allen, and Harley Bozeman; (second row) V. Matt Milam Sr., Charlie Smith, J.R. Madden, J.H. Martin, D.F. Shell, W.D. Walker, John D. Holmes, and Sheriff Bryant Sholars; (third row) Mack L. Branch, W.O. Everett, W.W. Allen, J.N. Woodard, Dr. F.C. Wren, B.G. Pasco, and J.G. Russell Sr. The boy at the door is Robert Oglesby. Because of the rich history of politics in Winn Parish, many of these men played an important role in leading not only their parish but the state as well. The history of Winn's influence on state politics actually goes back many years. In the post–Civil War days, Will Strong, owner of the *Southern Sentinel* in Winnfield, was named Louisiana's secretary of state. (Courtesy Louisiana Political Museum.)

The working people of Winn Parish had a cause and were waiting for a prophet. That prophet came in the form of a young local man who had gained Louisiana's attention as state railroad commissioner. Huey Long (right) and close buddy Harley Bozeman became traveling salesmen after leaving high school, selling books and Cotelene Shortening. Using Cotelene, Rose McConnell (center) won a cake cooking contest and Huey's heart. She later became his wife. (Courtesy Louisiana Political Museum.)

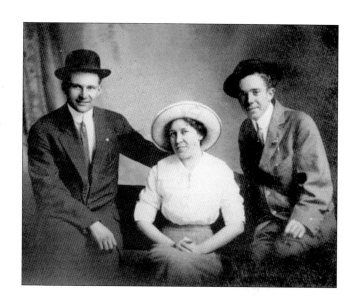

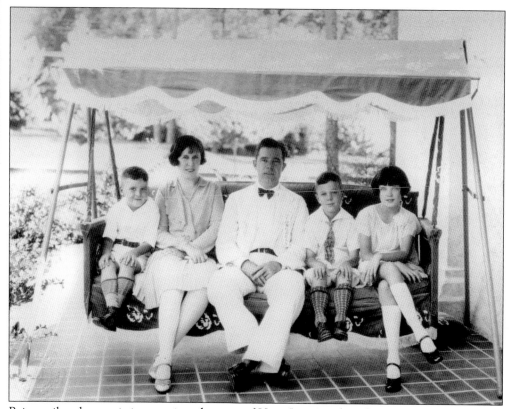

Being railroad commission was just the start of Huey Long's political career. He went on to be elected Louisiana's governor in 1928 and a US senator in 1930. Photographed at his 305 Forest Street home in Shreveport, Louisiana, are Huey and his young family. Smiling for the camera are, from left to right, Palmer, Rose, Huey, Russell, and "Little Rose." (Courtesy Louisiana Political Museum.)

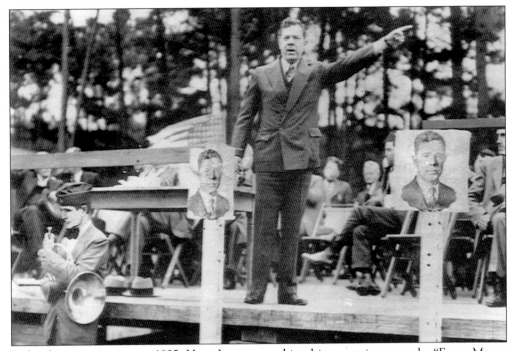

Before his assassination in 1935, Huey Long was taking his campaign to make "Every Man a King" to the people in his bid for the presidency against incumbent Franklin Roosevelt. In a time before electronic media coverage, campaigning was an up-front and personal process, as candidates went around stumping, speaking out to share their philosophies and to woo the public vote. (Courtesy Greggory Davies.)

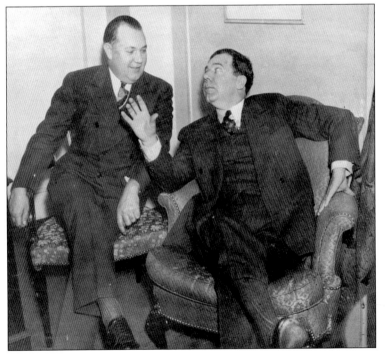

Huey Long was a master at working with—or even controlling—other policy makers in his unending quest for power. He had charisma and a wonderful knack for working the crowd and individuals to achieve his ultimate goals. In this conversation, Long sits confidently in an easy chair while talking with James Noe, who would later become governor of the state. (Courtesy Louisiana Political Museum.)

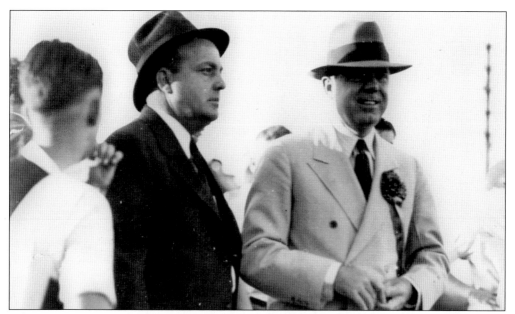

When Huey Long rose to power, he rewarded his childhood friends who he trusted. E.N. "Jack" Jackson, formerly of Winnfield, became the treasurer for the LSU system. He was Shirley Jackson's oldest brother and grew up with Huey. Other of Huey's friends included George Wallace (secretary of the Louisiana Tax Commission), Harley Bozeman (a state representative) and O.K. Allen (Huey's handpicked successor). (Courtesy Louisiana Political Museum.)

Huey Long could speak to ambassadors in one room and common folk in the next and be accepted equally by each because of his adaptive demeanor. He loved to incorporate his rural upbringing into his campaign rhetoric, a favorite being the making of "potlikker," to prove his point. (Pot liquor, usually served with corn bread, is the liquid remaining in the pot after greens are cooked down.) (Courtesy Louisiana Political Museum.)

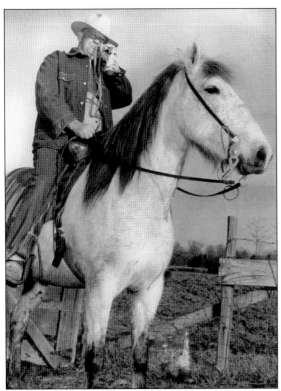

Unlike Huey, whose eyes were set on Washington, brother Earl Long's heart never left Winnfield. The three-time governor loved to return to his Pea Patch Farm and loved to hog-hunt in the area, often on horseback. At that time, hogs were raised as free-range animals, with owners registering ear notches in the clerk's office. Earl's hog pens were on the Dugdemona River bottoms. (Courtesy Louisiana Political Museum.)

A young Earl Long (left) in his first state post as lieutenant governor looks over legislation with Rep. O.K. Allen (later governor) and Gov. Richard Leche (later indicted). After Leche was removed from office in 1939, Long became governor. He was elected to full terms in 1948 and 1956. With that success, he sought and won his bid for election to US Congress in 1960 but died before he could take office. (Courtesy Louisiana Political Museum.)

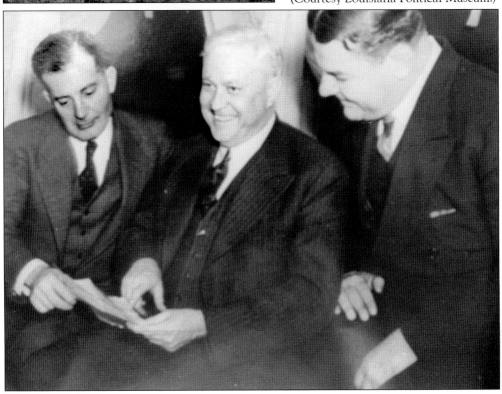

"Uncle Earl" Long's Winnfield home was his beloved Pea Patch Farm, located on Grove Street. The house was simple but like Grand Central Station for dignitaries who would come for an audience with Long. He often held court on the porch, dressed in his pajamas, settled in a rocking chair with a cowhide bottom. Standing in front of the home here is one of its caretakers. The Pea Patch was destroyed by fire in the 1960s. (Courtesy Louisiana Political Museum.)

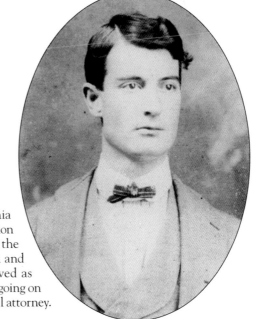

All four sons of Huey Long Sr. and wife Caledonia had an education and ended up in politics. Education was uppermost in the minds of this family, and the three daughters also received higher education and became teachers. Son Julius Tyson Long served as district attorney in Winn for a dozen years before going on to Shreveport and becoming an outstanding civil attorney. (Courtesy Louisiana Political Museum.)

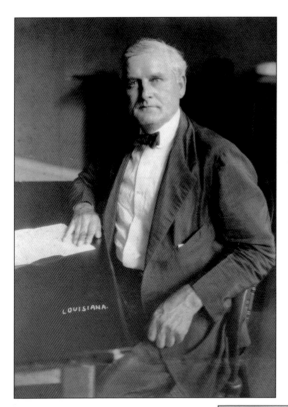

Dave Gaar, in about 1885, took over the sawmill, gristmill and cotton gin that had belonged to his father in their namesake community of Gaars Mill. Son James Wilburn Gaar (pictured) joined his father in the operation, and a general store was constructed. He had five sons of his own, and they all took their turns at the businesses. As a leader in his community and Winn Parish as a whole, James was elected as state representative in 1926. (Courtesy Miriam Skains.)

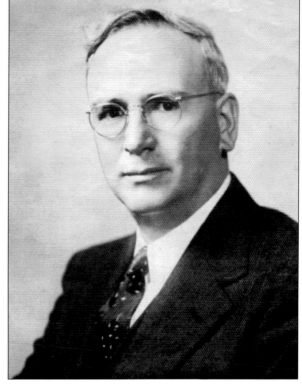

A. Leonard Allen was an educator, an attorney, and a member of the US House of Representatives, where he was an eight-term Democrat from 1937 to 1953. The younger brother of Gov. Oscar Kelly Allen, he was also a Scottish Rites Mason, a Shriner, and a prominent Baptist. (Courtesy Louisiana Political Museum.)

George Shannon "Doc" Long was a member of the powerful Long Dynasty of Louisiana and a US Representative. A dentist by profession, the oldest of the Long brothers practiced in Georgia, Kentucky, Louisiana, and Oklahoma. An Oklahoma state representative, he was later elected to Louisiana's Eighth Congressional District. (Courtesy Louisiana Political Museum.)

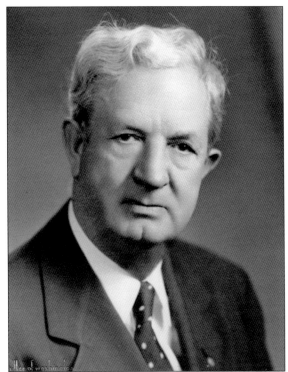

Another Winnfield politician, Gillis Long was born and reared here. He was elected to Congress for the Alexandria district in 1963, taking Harold McSween's place. A member of the Democratic Party, Gillis Long was an investment banker and attorney. A World War II Purple Heart recipient, he maintained a law office in Washington, DC, and was authorized to practice before the US Supreme Court. (Courtesy Louisiana Political Museum.)

In 1950, Puckett Willis became the youngest member elected to the Louisiana Senate. He was involved with the family's community store and was active in the small community that had been incorporated five years earlier and was known as the Village of Sikes. By profession, Willis owned and operated Merchant's Insurance Agency in Winnfield. (Courtesy Louisiana Political Museum.)

Ashton Collier was a Democratic member of the Louisiana House of Representatives from Atlanta. He served interrupted terms from 1956 to 1960 and again from 1964 to 1970, resigning midway through his third term. He was preceded in office by J.M. Breedlove. Holding that office until Collier's reelection was P.K. Smith, who would later become a prominent automobile dealer in Winnfield. (Courtesy Louisiana Political Museum.)

Eight

THE MILITARY PERSPECTIVE

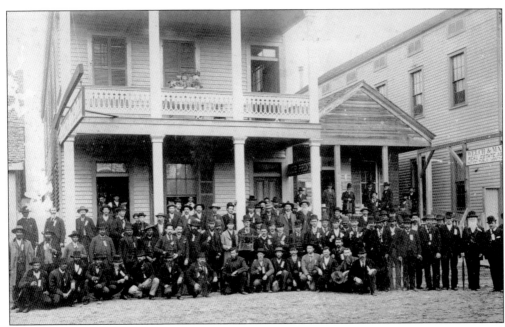

The general sentiment in 1861 Winn Parish as Civil War loomed was against secession. David Pierson, elected to represent Winn at the secession convention in Baton Rouge, honored that sentiment by voting no. Yet despite the Free State of Winn, many here, including Pierson, joined the South's cause, adding eight companies to the Confederate army. Many also joined the Union army. This classic photograph includes many valiant war veterans. (Courtesy Miriam Skains.)

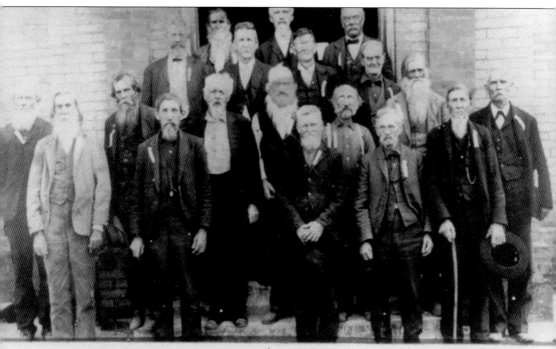

CONFEDERATE VETERANS.
WINN PARISH

ROW: LEFT TO RIGHT: JOHN G TEAGLE, GEORGE W. STORY, DR. SPENCER M.
TH, GEORGE A. KELLY, JESSE WOMACK, WILL A. STRONG, DAVID F. DUNN, JAMES D. L
TON ROW: LEFT TO RIGHT: WILLIAM MURPHY, ROBERT C. JONES, MIKE W.
S, JOSEPH SMITH, A. R. BUTLER, JOHN J. DICKERSON, WILLIAM F. SHUMAKE
IS BERNSTEIN, PHILLIP BERNSTEIN, JOSEPH M. PLUNKETT, J. MATT. McCAIN.

These surviving Confederate veterans were photographed years after the end of the Civil War. Included in this image are, from left to right, (first row) William Murphy, Robert Jones, Mike Long, Joseph Smith, A.R. Butler, John Dickerson, William Shumake, Morris Bernstein, Phillip Bernstein, Joseph Plunkett, and J. Matt. McCain; (second row) John G. Teagle, George Story, Dr. Spence Smith, George Kelly, Jesse Womack, Will Strong, David Dunn, and James Long. The Civil War took its toll on the lives of brave young men from Winn Parish and across the South and left the country in a demoralized state. But Appomattox did not bring an end to Winn's woes. If the inequities of Reconstruction were not bad enough, the scourge of the West-Kimbrell Clan, which preyed on westbound travelers made life perilous. A third indignity came in 1868, when one-third of Winn's acreage was taken in the creation of Grant Parish in a move to reward Union loyalists. (Courtesy Greggory Davies.)

Tennessee-born Edward Davies (Garrett) was studying medicine when he joined the Confederate Home Guard in 1861. Wounded through the lung in conflict at Corinth, Mississippi, he returned home after the war to complete his studies and to practice medicine. But Dr. Davies, dismayed with Reconstruction, followed the Harrisonburg Road to north Louisiana. He was principal of the Winnfield Male & Female School and started the first public library here in the 1880s. (Courtesy Greggory Davies.)

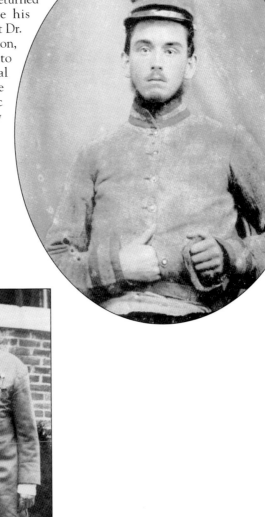

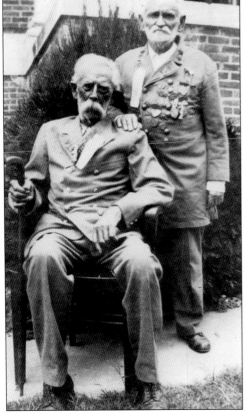

Proud Civil War veterans with medals in this photograph are Antone Radesich (seated) and W.E. Dark. In 1932, "Uncle Antone" told a seventh-grade history class that, at the age of 14, he left home and volunteered for service with 124 others under the leadership of Col. William Walker. Only 20 of those men lived to return home after the war. Radesich was a community leader here through the difficult years following the war. (Courtesy Louisiana State Library.)

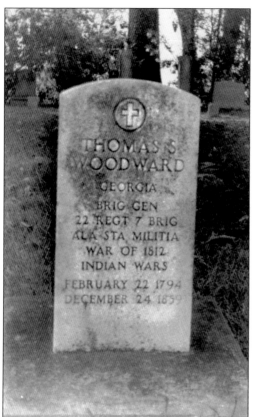

Born in Georgia, Thomas Woodward was a private in the War of 1812, where he met Andrew Jackson and became close friends with the future president. By his actions through various Indian conflicts, he rose to the rank of general. Later, as a successful businessman and planter, he helped found the towns of Tuskegee, Alabama, and Camden, Arkansas. After losing his family, he moved to Wheeling and founded the town of Montgomery in 1840. The general died at his home in Hargis and was buried in full uniform.

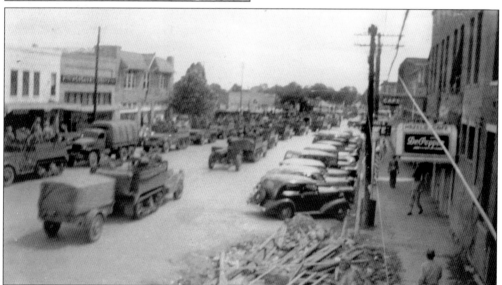

Times were exciting in 1941 for folks in Winnfield and throughout the 3,400 square miles of Louisiana bounded to the west by the Sabine River, to the east by the Calcasieu River, and to the north by the Red River. In the largest training exercise ever staged in the United States, 500,000 soldiers "invaded" to participate in the Louisiana Maneuvers, Red Army against Blue Army, in preparation for entering the war in Europe. (Courtesy Frances Walker.)

The war maneuvers, planned since the spring of 1940 and enacted in August and September 1941, meant high adventure for youngsters. Soldiers, equipment, and convoys were everywhere as the armies prepared to collide. Some 300 airplanes were involved in the exercises, and soldiers were posted on rooftops (here, on the Max Theime Building) as lookouts. Local Boy Scouts were also trained and posted atop First Baptist Church. (Courtesy Greggory Davies.)

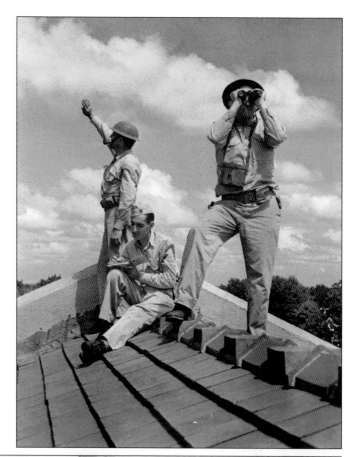

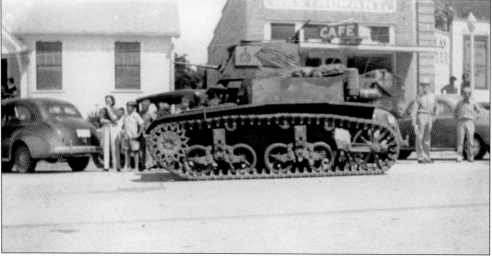

The town was awash with military activity during the 1941 exercises. Tanks, personnel transports, and supplies rolled down Main Street. Soldiers were bivouacked in the woods and fields in the area and were generally welcomed by Winn's residents. Soldiers on rations relished home-cooked meals and fresh water when they could get them and flooded the town on payday in quests for candy, cigarettes, soft drinks, ice cream sodas, and entertainment. (Courtesy Frances Walker.)

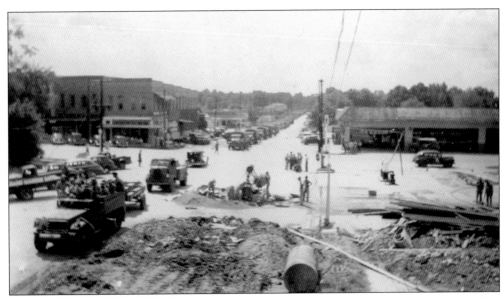

A convoy crosses Court Street on Highway 34 from the south during the war maneuvers. The smaller Red Army of north Louisiana, commanded by Lt. Gen. Walter Krueger (and including Maj. Gen. George Patton and rising star Col. Dwight Eisenhower), repelled the invading Blue Army of south Louisiana in the first exercise and then outflanked them at Shreveport in a surprise sweep through east Texas, ending the Louisiana Maneuvers. (Courtesy Frances Walker.)

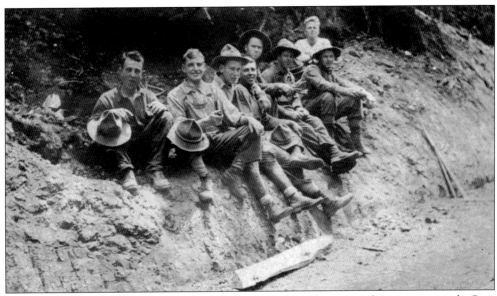

Taking a break from the war games, these young men relax. These were the testing grounds. Gen. George Marshall stated, "I want the mistakes made down in Louisiana, not over in Europe." There were fatalities, but only 26 (due to lightning, accidents, and heart attack), fewer than circumstances might have foreseen. One unfortunate young man was bitten as he put a "pretty snake" in his pocket, one local resident recalls. It was a deadly coral snake. (Courtesy Helen Maloy.)

During their time on maneuvers in Winn, many young men made friends with the locals—especially the pretty young ladies—and continued correspondence once deployed to the actual war. Often, the correspondence ended without explanation. One such young man was Joseph Simon, perhaps from Ohio, who wrote regularly to Helen Smart. His last mailing contained this photograph from Europe, receiving a medal from Gen. George Patton. (Courtesy Helen Smart.)

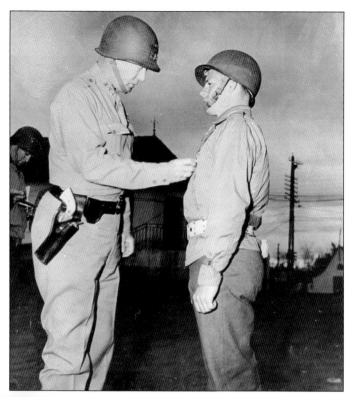

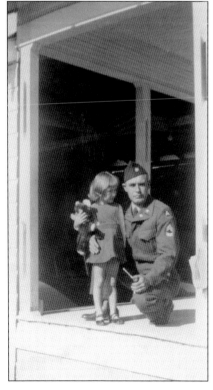

Soldiers, when away from home, missed their families more than at any other time. Home leave was always a special celebration, when the young men took every opportunity to be close to their loved ones. Here, Sharon Parker is shown while at home with his daughter, Sharon Gail. (Courtesy Nan Collins.)

Family ties reached out to extended families, especially when some of the family members were called to serve their country, putting the soldiers' lives at risk. When they came home on leave, it was no surprise that families would come together to catch up on lost time. Relaxing in this photograph are, from left to right, Mary Kelley, John Kelley, Lessie Kelley, Kate Kelley, and "Highball" Kelley.

Military buddies gather to swap war stories in this World War II–era photograph from around 1943. Their tales had to be great—and possibly grew in the telling—since the young men represented different branches of service. In this photograph are, from left to right, Leland Ferguson, Prentis Ferguson, Darden Orendorff, Milton Orendorff, and Orin Ferguson, who all met up in Germany. (Courtesy Vara Smith.)

Nine

VIEW OF OUR LIFESTYLE

Winn was a poor agricultural community where all members of families had to work on the small farms to eke out a living. In the early times, school schedules were altered to allow youngsters to assist with the harvest. This common scene is of a family, young and old alike, together on their horse-drawn farm equipment, holding a somber pose for the camera. (Courtesy Helen Maloy.)

In times before electronic entertainment, Winn's children had to find their recreation on their own, generally outdoors. Popular sites included Gum Springs, Cloud Crossing, and Coochie Brake. Pictured before the ancient rocks, surrounded by swamps, were mined as quarry materials, the brake was described as a "mycologist's paradise." The FBI even busted moonshiners hidden in its out-of-sight areas. (Courtesy Vara Smith.)

When families needed to wash their car, it was easier to drive it to the closest creek ford than to draw precious water from the home well. In this family scene in the Sikes area, young Earline Usrey (Gonzales) is a big help, washing the bumper and headlights, while her mom, Nellie Usrey, washes the door (center). Cousin Lena Emmons (in hat) pitches in, too. (Courtesy June Melton.)

Creeks around Winn Parish through the years have been a source of recreation in the forms of swimming and fishing. The latter, in fact, has also helped sustain families by putting food on the table during early and hard times. This pastoral scene shows young families watching patiently as their provider waits for a fish to bite.

The Winn Parish Library system was born in 1937 as part of a three-parish demonstration. Local voters in 1940 approved a two-mill tax to support their own library. Bookmobiles provided an extension to rural areas of the library's reach and traveled all over Winn Parish. In this 1938 state photograph, a young boy looks over a book he's just borrowed from the bookmobile. (Courtesy Louisiana State Library.)

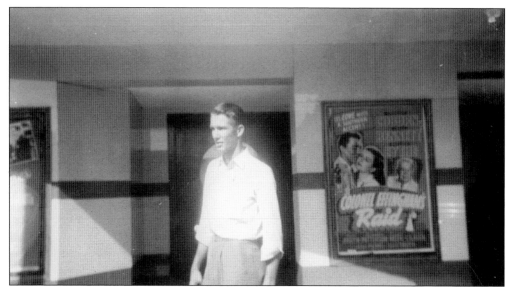

The movie theater was a central attraction for Saturday entertainment in small towns. Winnfield was luckier than most, as it had two theaters and later a drive-in. Adults tried to avoid matinees because theaters were packed with children enjoying a cartoon and the weekly serial prior to the double-feature—all for a bargain price. Above, Virgil Jones comes out of the Venus Theater on Court Street, past the promotional poster for *Colonel Effingham's Raid*. (Courtesy Helen Maloy.)

The Gum Springs recreational area is a part of the US Forest Service, Winn District, in the Kisatchie National Forest. The spring-fed pool created a shallow swimming area that became a popular destination point on hot summer days for children and youths (both from Winn and from across the region) who would make an entire day's adventure out of an outing to the swimming hole. (Courtesy US Forest Service.)

Families raised their children at the Gum Springs area during the summer months, finding it to be a safe environment for all sorts of activities. Boy Scouts camped there and earned merit badges while learning outdoor skills. Brownies and Girl Scouts also received badges for cooking and swimming. Often, while children swam, mom and dad would get a picnic ready as friends visited. A young lady tests the waters in this photograph. (Courtesy Helen Maloy.)

The original development and construction of facilities at the Gum Springs recreation area was undertaken by the young men of Franklin Roosevelt's CCC. Projects included pavilions, picnic tables, bathhouses, fireplaces, trails, and an extensive series of stone steps leading down to the swimming hole. The pool area itself had a concrete bottom to contain the natural spring waters. The swimming facility was lost in the mid-1960s when the concrete buckled and water contamination was reported. (Courtesy Helen Maloy.)

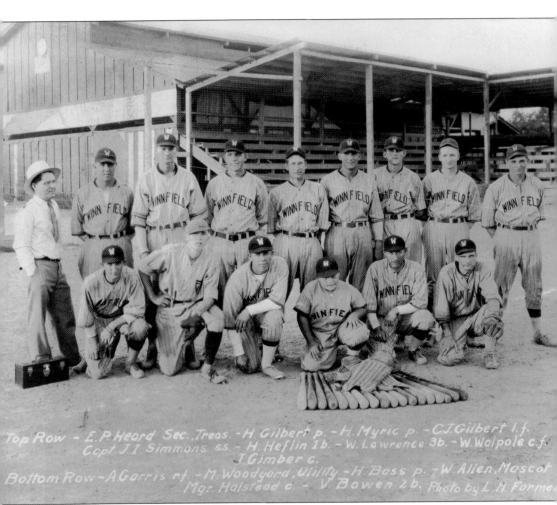

Top Row - E. P. Heard Sec. Treas. - H. Gilbert p. - H. Myric p. - C. J. Gilbert l. f.
Capt. J. I. Simmons s.s. - H. Heflin 1b. - W. Lawrence 3b. - W. Walpole c. f.
J. Gimber c.
Bottom Row - A. Garris r. f. - M. Woodyard, Utility - H. Boss p. - W. Allen, Moscot
Mgr. Holstead c. - V. Bowen 2b. Photo by L. H. Farmer

In the early 1900s, high school athletic programs were being organized for the first time. Winnfield joined the North Louisiana High School Association in 1909 so that literary and athletic activities might be encouraged. The following year, the baseball team played New Orleans, winning three of the five games to win the state high school pennant. The batteries were Charlie Smith and Tom Huffman and Hasson Morris and Jack Wallace. Catcher "Happy Jack" Wallace went on to play for the Chicago Cubs and was several times manager of the year in the Southern Minor League. The games were played in the old Wallace Ballpark, now the site of the Winn Parish Medical Center helicopter pad. At the time, semiprofessional ball was also prevalent in rural communities like Winnfield.

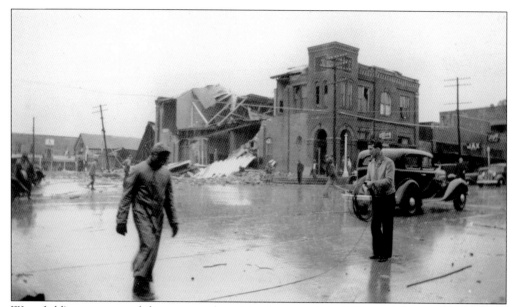

Winnfield's worst natural disaster struck on Monday, March 4, 1935, at 1:30 p.m., when a storm from the southwest spawned a tornado (which folks today still refer to as the "cyclone"). It cut a zigzag path through town in less than three minutes, damaging or destroying 214 buildings. City hall suffered $35,000 in damages, and though it was not destroyed, it lost its famous bell tower. (Courtesy Frances Walker.)

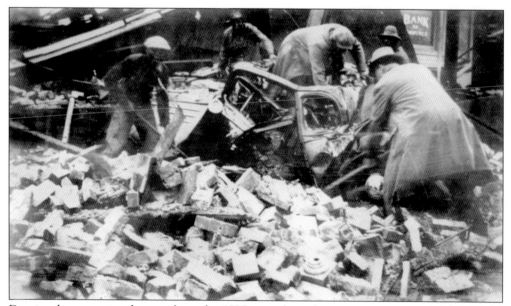

Despite the extensive damage from the 1935 tornado, only one person was seriously injured. The one person thought to be killed was later discovered in the rubble only slightly bruised. Rains that accompanied the severe storm caused damage to the buildings that had lost roofs to the winds. A total cost figure of damages was put at $200,000, a lot of money in those times. (Courtesy Frances Walker.)

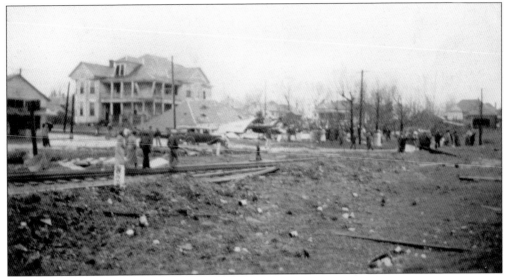

Of the 214 buildings destroyed by the 1935 tornado, only 49 property owners had tornado insurance. Residents rallied to repair power and communication lines, and rubbish was cleared in less than three days. Mayor R.W. Buce received $150,000 in federal aid for repair work for the town. The federal government also issued a grant for $28,651.71 for the reconstruction of Winnfield City Hall, which did not have insurance. (Courtesy Frances Walker.)

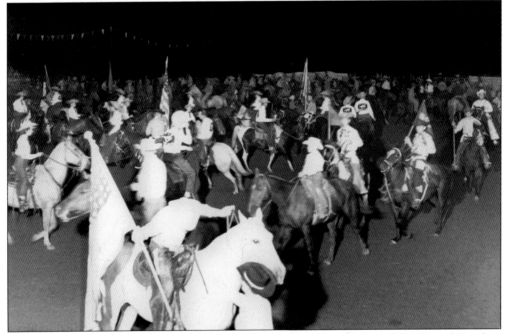

Winn has traditionally held its parish fair the last week of September and the first of October. The rodeo has been a traditional part of the fair. Riding clubs across the parish were a great part of the recreation for young and old alike, since most owned horses. The grand entry of the rodeo was special, as many varied clubs converged on the parish arena, carrying their flags and banners with pride. Riding, roping, and other competitions would then follow. (Courtesy Winn Parish 4-H.)

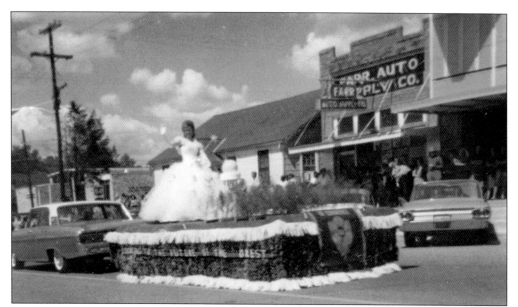

Initially held in conjunction with the Winn Parish Fair, in 1948, the state legislature (with urging from Gov. Earl Long) provided funding to help establish the Louisiana Forest Festival here. The income provided a platform for major forest operations to come in with equipment and more to promote the forest industry. Local organizers also set up an entertainment side of the festival, with competitions including "Coon on a Log," timber sports, and the queen's contest. (Courtesy Ernie Peterson.)

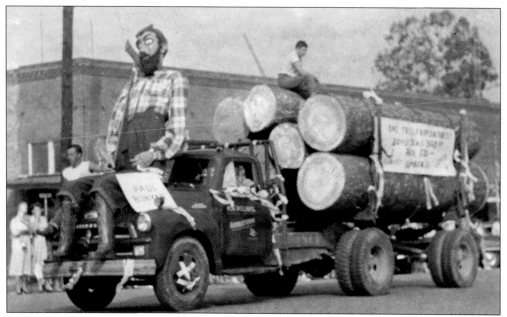

The original Louisiana Forest Festival continued as a popular annual attraction through the mid-1950s, when legislative funding ceased. It was supported by Louisiana's timber companies, since it could be used as a teaching tool about forestry in the state. The festival always opened with a grand parade through downtown. In this photograph is the festival's original Paul Bunyan, together with huge pine logs on a vintage truck. (Courtesy Tremont Lumber Co.)

A popular inclusion in the Forest Festival was timber sports. Competitions included all aspects of logging practices that these men used daily to make a living, turned into sport for fun and prizes. Shown here is hand-loading of pulpwood, each stick being eight feet long. The fastest time (and best load, per poundage) won the prize. Modernization has eliminated this practice. (Courtesy Louisiana Forest Festival.)

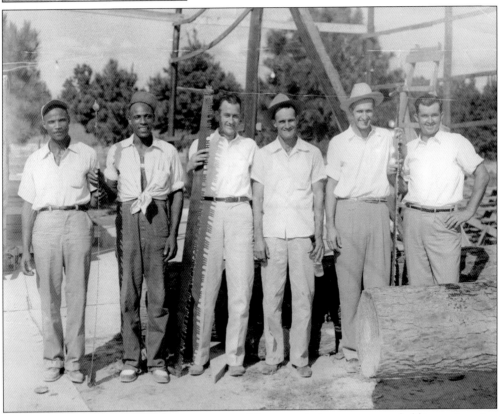

The two-man crosscut saw competition was one of the many timber-sport events held in conjunction with the Louisiana Forest Festival each fall. Winners must cut a perfect "round" out a log in the fastest time. Other manual events included chopping and one-man buck sawing. The festival was reinstated in 1980. Timber sports now add many mechanical saw events plus heavy equipment skills to a list of manual events. (Courtesy Tremont Timber Co.)

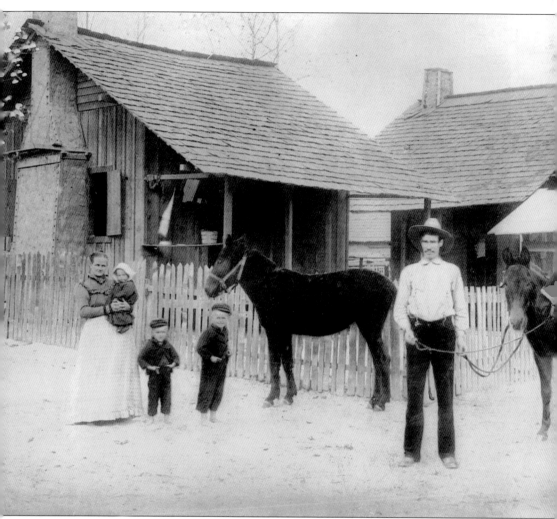

Isaac "Paw" Head and family stand in front of their Sikes home in 1907. Considered on the wealthy side for the era, the front of the house was a separate kitchen, with sleeping quarters in the rear. A smokehouse stood between. The chimney is made of mud, and the roof shingles are rived wood. The kitchen's window provides air circulation so that cooking is bearable. The brush broom hanging on the porch was used daily keep the yard clear of vegetation and free from chicken droppings. The fence that enclosed all three buildings was an indication of prosperity. They had three mules, including their favorite, Crockett. The family lived all their lives in Sikes and included eight children altogether. The baby pictured is Plina Pauline, who grew up to become a long-term mayor of Sikes. (Courtesy Rita James.)

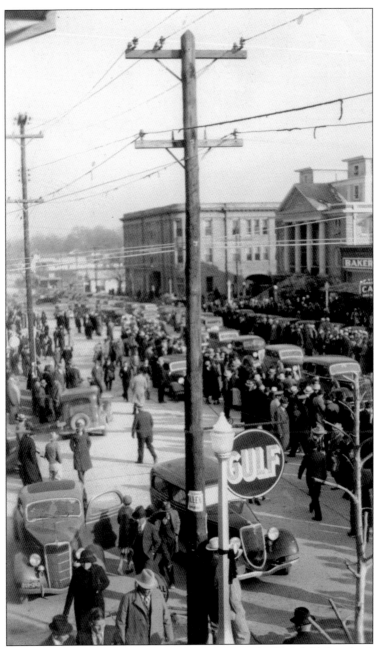

O.K. Allen, chairman of the state highway commission, was the Kingfish's handpicked successor for governor in 1932, when Long was elected to the US Senate. Allen died suddenly in office in 1936. His funeral at First Baptist Church was one of the most momentous events in the history of the city. His unexpected death created some turmoil at the state level. Though Lt. Gov. James Noe succeeded Governor Allen in office, Richard Leche (with Earl Long as his lieutenant) won the post in fall elections. A year before, Huey Long had been assassinated. Allen's death also shook the local community, which had lost one of its own. They had assumed he would finish his term and live to a ripe old age at home. In this photograph, Main Street is lined with mourners and a solemn line of cars for the fallen governor. (Courtesy Frances Walker.)

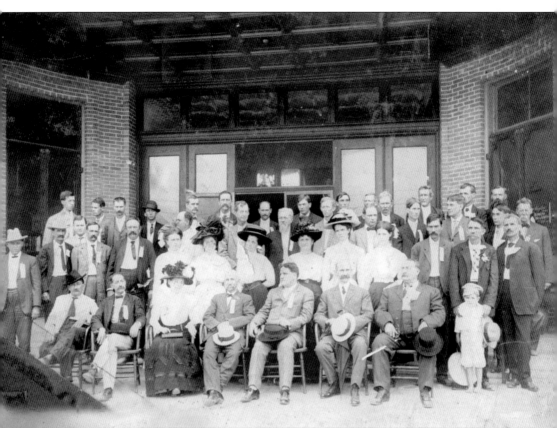

Eastern Star Lodge No. 151, F&AM, was started in 1857 when a group of Masons living in Winnfield applied to the Louisiana Grand Master seeking a dispensation to form a new lodge. The first meeting was held on September 24, 1857, with the following three principal officers: Worshipful Master Golden Hicks, Senior Warden William Walker, and Junior Warden Asa Emanuel. The 15 other charter members were Philip Bernstein, Q.A. Hargis, R.C. Sims, James Brock, J.W. Stovall, Samuel Earnest, William Luckey, William Stone, E.W. Edwards, John Mathis, Benjamin Ussery, Charles Parsons, Jesse Womack, Joseph Green, and Samuel Rogers. All were early parish leaders. Asa Emanuel was Winn's first sheriff. William Walker became a lieutenant colonel of the 28th Louisiana Infantry and was killed at the Battle of Mansfield in 1864. The lodge's original bylaws and complete set of minutes are believed to be the second oldest complete written records in the parish, Hebron Baptist Church having the oldest. Winnfield played a significant role in the state organization and was the setting of a Past Masters Convention, which was captured in this portrait at the entrance of the Winnfield Hotel. (Courtesy Louisiana Political Museum.)

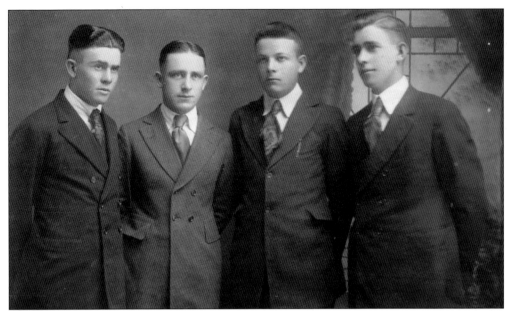

The arts and cultural activities were at the forefront of school curriculums during the first half of last century, helping broaden the education of students. Theater groups, choirs, bands, and literary societies were all in full swing. In 1909, the high school's move to join the North Louisiana Association was not just for sports but also to enhance cultural development. This WHS quartet includes, from left to right, Gordon "Red" Dickerson, Lawrence Gates, Hermie Shows, and Otto White.

A handwritten invoice dated 1914 from Winnfield Bottling Works gives readers an insight into the cost of consumer items in those days. Located just off Main Street, the local manufacturer produced soda waters, ales, and ciders. Even in those days, there was a freight charge to businesses receiving cases of their product. There was also a nickel charge for each bottle not returned. (Courtesy Vara Smith.)

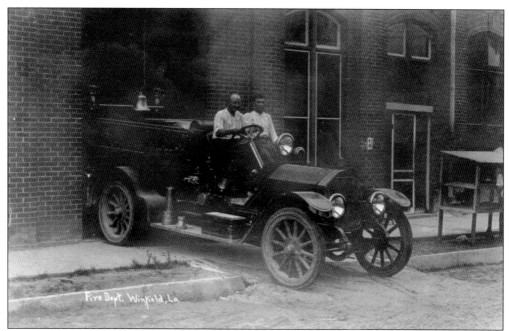

In the early days, the Winnfield Fire Department was housed on the Beville Street side of city hall. Though the front part of the building was damaged by the 1935 cyclone, this portion was not. Only the fire chief was paid, so volunteers provided the crucial link to the city's fire protection. A vintage engine rolls out of the station in this photograph.

A lasting memory for a child could be created when a traveling photographer passed through town to take family portraits. One of the favorite props for children brought by the photographer was a pony in full show tack. In this image, young Barbara Ann Abrams does not seem sure that she wants to be astride her mount. (Courtesy Helen Maloy.)

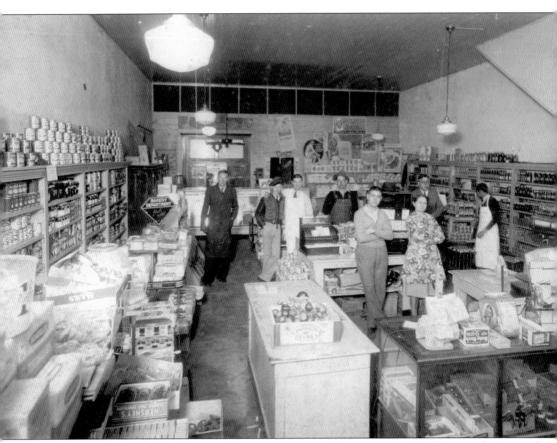

Today's generation has grown up with corporate-owned chain stores and online purchasing and so has little understanding of the traditional mom-and-pop store that was so essential to small-town life. Pete's Grocery, always located around Courthouse Square, was a good example of the important relationship between business and customer. The grocer had daily delivery service, extensive credit for his customers (even when times were tough), and very long hours; he was open until midnight on many days. Though his name was Henry Arthur Peterson, everyone knew him as Mr. Pete. (His wife, Bessie, always addressed him as Mr. Peterson rather than Pete.) Peterson came to Winn Parish to assist B.F. Stovall of Dodson with a going-out-of-business sale and stayed to open his own business in Winnfield. The business thrived, particularly during the World War II years. He died in 1958, but the business remained open until 1961, when his widow and son sold it. (Courtesy Ernie Peterson.)

Ten

OUR SCHOOLS
AND CHURCHES

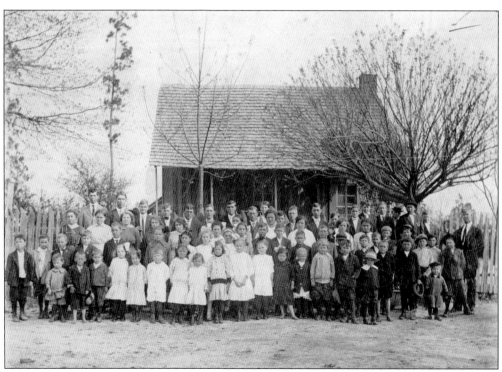

Standing as a monument to the pioneers of Winn Parish, the modern public schools reflect a struggle of more than 120 years to keep local educational facilities abreast of changing trends. In the early days, school principals were respected leaders of their communities. This 1918 photograph shows students and teachers of Gaars Mill School standing in front of the principal's home, which was a quarter-mile from the school. Note the neat dress of the children. (Courtesy Elois Falkes.)

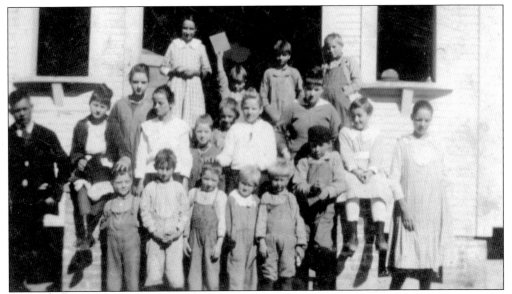

In a photograph taken prior to 1923, the teacher at the one-room Brister School stands on the steps of the little schoolhouse with his students. In the Hebron community, the building is listed on the National Register of Historic Properties and is now being maintained by local volunteers. It is currently used for community functions. The school's heyday was in the first quarter of the 1900s. (Courtesy Helen Maloy.)

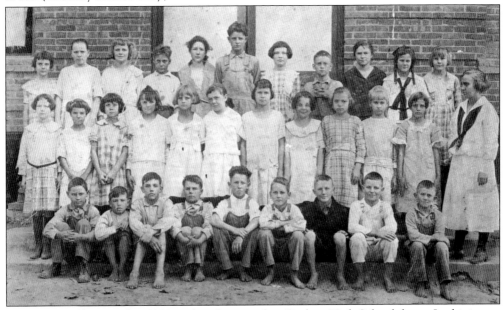

Shoes were still optional in 1921, as this photograph at Dodson High School shows. In this image are, from left to right, (first row) Travis Davis, Bootie Jordan, ? Price, Edward Walters, Hermon Pruner, Zeb Pruner, Harper Terrill, Loyd Stovall, and Murphy Barr; (second row) Mamie Sherman, Jay Kornegay, Edna Terral, Emily Barr, Grace Anders, two unidentified, Loyce Pennington, ? Hagar, ? Veneta, Jannie Sanders, and Molly Davis (teacher); (third row) Ruby Pennington, Pauline Emmons, Esther Branch, Ponkey Hutson, ? North, Paul North, Denice Scott, ? McDonald, Helen Hughes, Juanita Clark, and Loyce Hagen.

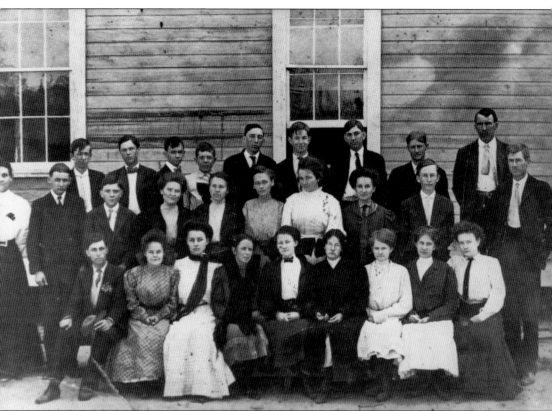

This picture was taken in 1909 of grades 9, 10, and 11 at Winnfield High School. This is believed to be the best "schoolboy" photograph of Huey P. Long, age 15 and in grade 10. Posed for this photograph are, from left to right, (first row) George E. Bozeman, Mary Dale, Clara Cotton, Audie Williams, Mae Crawford, Onie Teddlie, Ruby Scarbrough, Ruby Moss, and Ethel Allen; (second row) Bettie Nolan (teacher), Henry Willis, Webster Godfrey, Katie Lee White, Nancy Long, Tamzy Bozeman, Rubie Wasson, Ida Wallace, John Peters, and J.P. Liggin (teacher); (third row) Averett Watts, Glen Durham, Harley Bozeman, Huey Long, Sam Godfrey, Everett Fick, Morrell Milburn, J.E. Maloy, and W.C. Robinson (principal). Before this time, students graduated after their 11th year. In 1909, the senior class received the surprising news that 12 years would be required for graduation. None of the 11th graders went on to take their senior year, however. Huey and his pal Harley attended school through the 11th grade but decided they had all the schooling they needed and began working as traveling salesmen. (Courtesy Peggy Bozeman.)

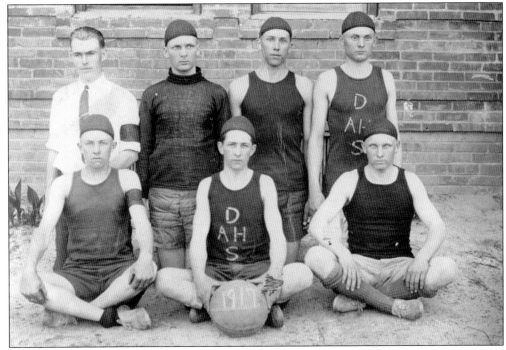

Louisiana high school athletics began to get organized in the early 1900s, and Dodson High School put together a basketball team. Of the coach and players included in this photograph, identified are C.B. Payne, Waymon Payne, and Dewey Sanders. Playing conditions were much more basic than the climate-controlled gyms teams now enjoy. Early players competed on dirt courts with simple baskets.

Shown in this photograph of faculty members at Sikes High School in the 1930–1931 school year are, from left to right, Roy Sanders, Ishael Crain (substituting for Una Johnston), Amy Norman, Zoulena Barnett, R.W. Collins, Gertrude Mixon, R.E. Oxford (principal), R.E. Emmons, Margaret Shell, Willie Kornegay, Mamie Mixon, and Ottice (Mrs. Roy) Sanders. Seated are Thalia Hearon and H. Vinyard. (Courtesy Nan Collins.)

Calvin High School seniors of the class of 1944 are, from left to right, (first row) Howard Bonnette, D.C. Carpenter, Dayton Carter, and Chester Chandler; (second row) Maurine Beal, Ethel Bonnette, Marie Guthrie, Joan Henningan, Trudy Moore Shecton, Christine Bullock, and Sammie Blake; (third row) Earl Bates and Robert Boone. Also in this class was Gladden Horn, who left early for service in World War II. (Courtesy Kathy Guin.)

This WHS band picture was taken in front of the old high school around 1951. Principal W.D. Walker stands to the left, with band director Bill Noonan to the right. The band members range from grades 8 through 12. The twirlers in the first row are, from left to right, Nancy King, Barbara Dickerson, Nellie Faye Sikes, Nancy Lynn Wells, Polly Sue Garris, Rose Nell Creel, and Johnnie Louise Frasier.

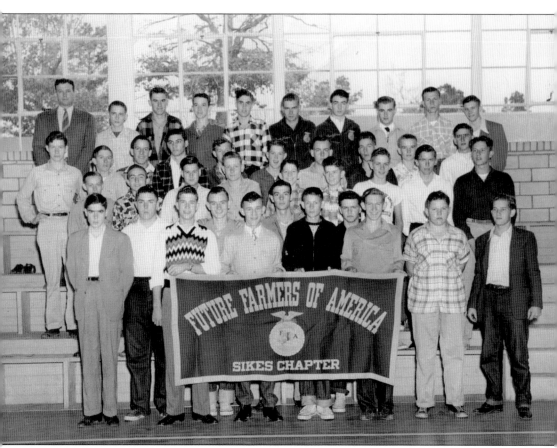

High school agriculture clubs play a vital role in the character and skills development of young men and women. Through the years, these clubs, like Future Farmers of America (FFA), 4-H, Future Homemakers of America, and Future Business Leaders of America, involved a large number of Winn's students. The 1940 Sikes High School FFA won high honors at the state fair. Included in this photograph are, from left to right, (first row) Jack Smith, Bobby Parker, Billy Beavers, Kenneth Simmons, Dudley Crain, Carl Peppers, Austin Abrams, Bob Emmons, James Hinton, Barry Bolton, and Harold Smith; (second row) Cedric Crain, Jimmy Newsom, J. Reese Crain, Howard "Red" Sanders, Frankie Simmons, Perk Thornton, Carol Hatcher, Buford Calhoun, and T. Ray Gregory; (third row) Billy Pilley, Doug Peppers, Chester Adams, L.D. Brister, Morris Vickers, Joe Womack, Alton McNaughton, Luke Sanders, Jimmy Hatten, and W.R. Roberts; (fourth row) John Mitchell (teacher), Archie Hatten, Lyndal Hatten, Benoit Crain, Jack Johnson, Stanley Vickers, Roy Johnson, Jimmy Parkers, Freddie Kidd, and Carmen Crain. (Courtesy Helen Maloy.)

Spring is always a proud time for high school seniors across the parish as they receive their caps and gowns in preparation for graduation. The 1951 seniors at Dodson High School posed for this photograph are, from left to right, (first row) Maxine Mooney and Sue Gates; (second row) Thera Lou Temple, Hazel Earls, Betty Vines, and Louise Dick; (third row) Kelly Bishop, Ike Bearden, Howard Ray French, Dan Waters, Dale Smith, and Karl Womack. (Courtesy Dale Smith.)

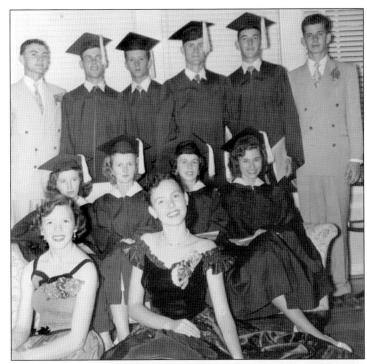

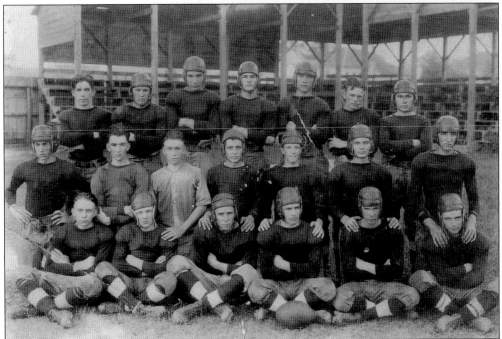

Winnfield has a proud football history, though teams found the going tough at the outset. Known as the Crimson Tigers for years, the high school's mascot lost its "crimson" description sometime during the war years, and they have been known simply as the Tigers ever since. This photograph shows an early team ready for competition. Notice the leather helmets without faceguards. (Courtesy Greggory Davies.)

115

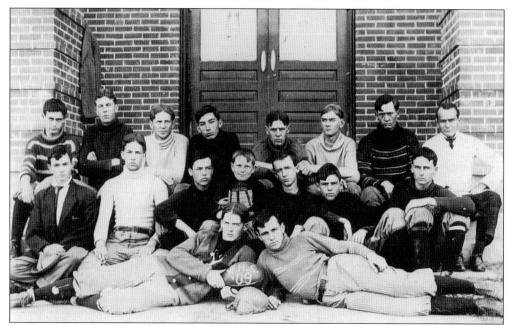

Records state that a credible football team for Winnfield was "definitely assured" in 1910 when Rawson Stovall, a former LSU grid star, was employed to coach the Winnfield 11. Games with Louisiana College and Alexandria were promptly scheduled. Plans for the first football squad were made the year before, as this group of young players poses at the front door of the old high school. The enrollment at Winnfield was 437. (Courtesy Greggory Davies.)

When the Winn Parish Library extended its service to rural Winn, Calvin had one of its first branches. Because of its proximity to the school, students quickly utilized library resources in their studies. Winn has historically enjoyed a readership considerably higher than state average. Calvin students enter their branch library in this photograph from the 1930s. (Courtesy Louisiana State Library.)

Prior to World War I, there were few public facilities for the education of black boys and girls in the parish. Around 1916, educational leaders realized the need for such a facility, and a two-story frame building named Winnfield Colored Public School was constructed on the present-day site of the Moss Street Gym. The Winn Parish Training School was located in Dodson during these years, but as the town's population decreased in the early 1930s, the school board decided to move it to Winnfield, where the two schools were combined and the name Colored Public School was abandoned. The school continued to grow, adding to its curriculum and expanding in size. The mid-1950s marked a new era for the school when it was formally dedicated as Pinecrest High School. In 1950, eight schools served the black students of Winn Parish. They were Dodson Elementary, McCarty No. 1, McCarty No. 2, New Enterprise, Old Morning Star, Phillips, Union Hill, and the Winn Parish Training School. (Courtesy Louisiana State Library.)

In 1908, William Phillips, a former slave, donated two acres to build a school and church for the African American community. It operated for 37 years, from 1918 to 1955, with an average enrollment of 50 students. Founded on the principle that education would improve one's life and total existence, the school year ran from October to February, allowing the children to be at home when needed for family farm duties. The schoolhouse was placed on the National Register in 2000. (Courtesy Isa Dee Hobdy.)

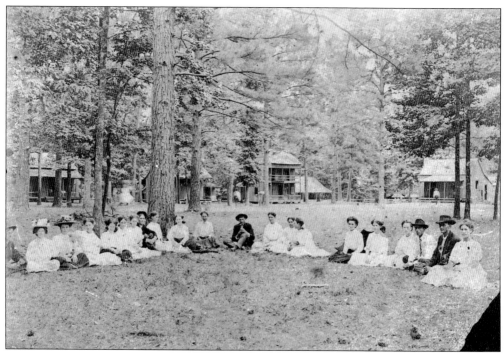

The Ebenezer Holiness Campgrounds were located near Wheeling and headed by James Madison McCain, a noted legislator and Civil War veteran. A beautiful hillside covered with trees and four natural springs was the site of this health resort, as well as one of the largest religious campgrounds in the south. The springs contained a medicinal mineral of "high curative value." A large tabernacle was built as well as a hotel and rooming houses.

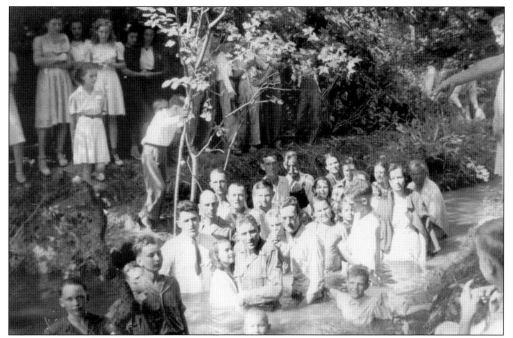

Here, deep in the Bible Belt, nothing says revival like an old-time baptism in the creek. This wonderful photograph from 1937 shows Rev. Calvin Robertson in a creek during a baptism with a flock of his First Assembly of God congregation. Other church members stand on the banks. While an outdoor ceremony is more scenic and exciting, baptisms have, for the most part, been moved indoors in modern times. (Courtesy Susanne Martin.)

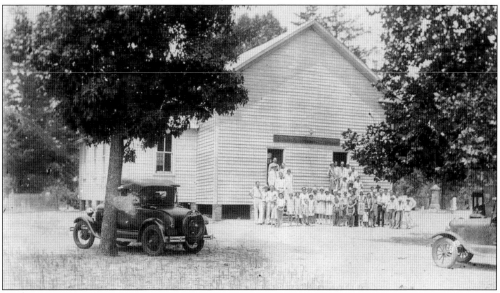

Mount Zion Methodist Church near Wheeling is one of Winn's earliest organized churches and has what is perhaps the largest rural cemetery here. Their first church was built in 1856 of pine logs and replaced in 1871 with a rough lumber structure that was used as both a church and a schoolhouse. Hand-planed lumber was used in a replacement building in 1898, and a brick-veneer building was constructed in 1956. (Courtesy Janee McDuff.)

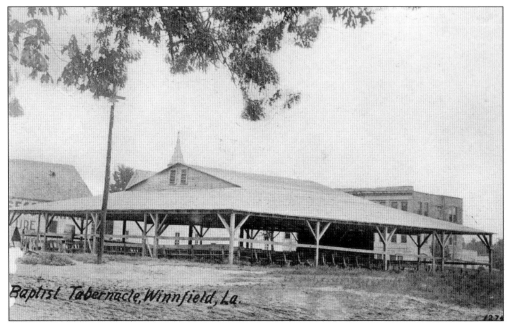

Baptist Tabernacle, Winnfield, La.

First Baptist Church of Winnfield was organized in 1871, and its first building was completed in 1903 on the corner of Main and Laurel Streets. The property had been purchased for $25 with proceeds from the sale of lemonade by the Ladies Aid Society. Shown is the tabernacle, built in 1913 for a June meeting by Dr. M.E. Dodd. It was later converted into Sunday school space, with walls and heating added for the winter months. (Courtesy Paul Peters.)

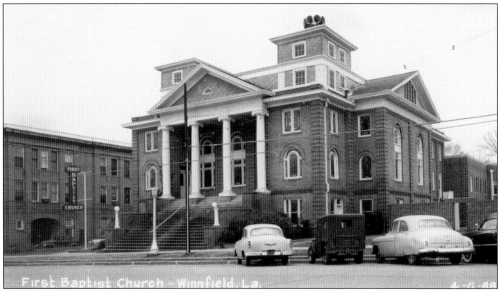

First Baptist Church – Winnfield, La.

The cornerstone for the first brick sanctuary of First Baptist Church was laid on April 25, 1920, and work continued through 1925, when the Louisiana Baptist Convention met there. Although work was not complete, the first sermon was delivered in the auditorium by Rev. L.D. Posey on December 3, 1921. The structure originally included the two towers flanking the cornice. The four pillars were added in a renovation. The towers and the fourth floor have since been removed, but the pillars and cornice remain. (Courtesy Greggory Davies.)

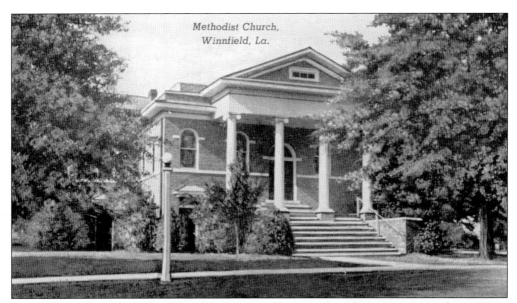

Methodist Church,
Winnfield, La.

Four different First Methodist Church sanctuaries have stood on the same one-acre lot on Main Street that was donated by Daniel Kelly in 1870. It has been known by three different names through the years—Methodist Episcopal Church South, First Methodist, and First United Methodist. The congregation met in homes and stores until the first church was erected. That first building served as a place of worship for both Methodists and Baptists. (Courtesy Greggory Davies.)

The Catholic church in Winn Parish began in 1907, with services being held in the courthouse. Members soon purchased a lot and built a frame church, St. Eleanor's, with a tin roof and dirt floor. That church was destroyed by fire in 1925, and in subsequent years, mass was held in various places, frequently in the home of R.T. Tucker. In 1945, a $5,000 grant allowed the construction of this brick church on Lafayette Street, renamed Our Lady of Lourdes. (Courtesy Louisiana State Library.)

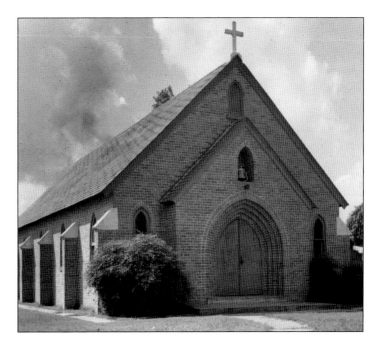

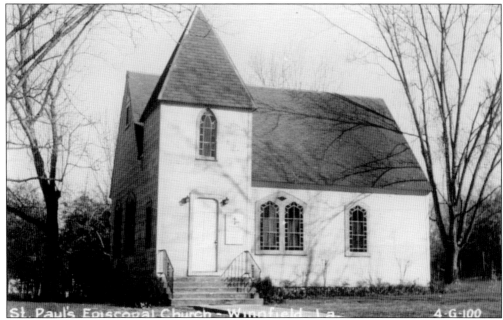

In the late 1930s, the faithful met in homes as efforts were made to bring an Episcopal mission to Winnfield. John and Phyllis Peters donated a lot on Pecan and North Boundary Streets, and the diocese secured an abandoned frame church from a Baton Rouge plantation. The building was moved piece by piece for reassembly on the lot. Worship at St. Paul's Episcopal Church continues to this day. (Courtesy Greggory Davies.)

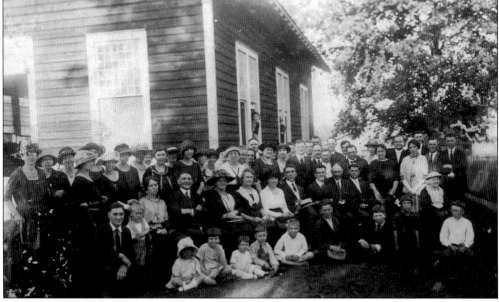

Winn's faithful have established churches of many denominations in local communities. Winn has been the focus of state events, hosting at least one Southern Baptist state convention (1925) and the state convention of Christian Churches of Louisiana (pictured). Familiar names within the crowd include Janie Cole, Eva Cole, Inez Boone, Don Turner, Albert Meek, and Cleodis Boone. (Courtesy Louisiana Political Museum.)

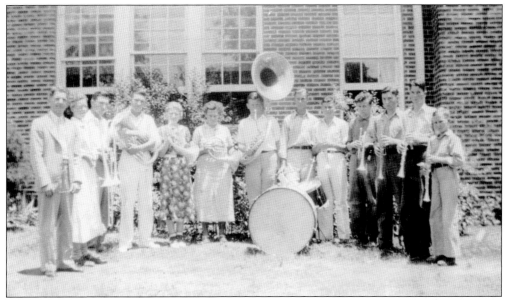

Through the years, Calvin High School has won a lot of attention on the basketball court and baseball and softball diamonds. Previously, the school boasted a band. This photograph is believed to be of the first Calvin band.

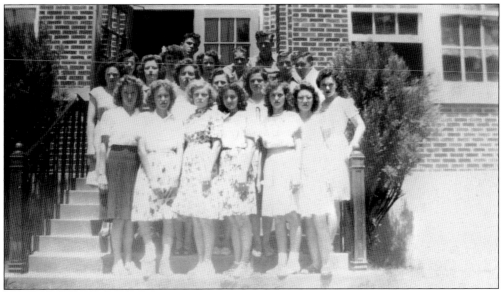

There were only a few young men in the postwar graduating class of 1946 at Sikes High School. Seniors included in this photograph are, from left to right, (first row) Vivian Smith, Helen Abrams, Bobbie Rae Branch, Betty Gates, unidentified, Bernadine Crain, and Voneta Hatten; (second row) Nadine Smith, Smokie Gulledge, Edith White, unidentified, and Sue Zenter. Two of the young men include Donald Coon and John G. McCarty. (Courtesy Helen Maloy.)

First Presbyterian Church of Winnfield was organized in 1908 with 27 charter members. In 1915, the church got its first full-time pastor, Rev. Alwin Stokes, who served a total of 38 years. Brother Stokes, as he was known, touched the lives of many youths through his involvement with Boy Scouts and coaching. He organized Winn's first Scout troop and was a volunteer coach at the high school, guiding the 1919 football team to the state championship. (The current football stadium is named for him and longtime principal W.D. Walker). Several months after Stokes's arrival in 1915, John and Mattie Hunt donated to the church a corner lot and house on Lafayette Street. The white frame sanctuary was used through 1961. The manse next door (previously the Hunt Lumber Company office) is still in use today. The cornerstone of the present brick building was laid in 1961. An outstanding feature of the sanctuary and the adjoining educational building is that they are constructed of woods native to Louisiana, primarily to Winn Parish. (Courtesy Jane Purser.)

Education was an important issue to the settlers of Dodson, and a tax was passed in 1901 to allow construction of their first schoolhouse. Five years later, a two-story brick building was erected—the first brick school in Winn. Major renovations in 1937 included the addition of a modern home-economics cottage, an auditorium, and a gymnasium. (Courtesy Louisiana State Library.)

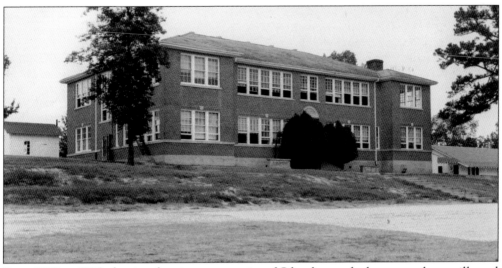

From 1910 to 1925, the tiny farming community of Sikes boomed when several sawmills and cotton gins followed construction of the Tremont Railroad in the area. Indicators of prosperity included two banks, a two-story hotel, the Ford Motor Company, cafés, a 12-room hospital, and this high school (with an enrollment of around 600). The boom ended when the mills closed and fire destroyed much of downtown in 1924. (Courtesy Louisiana State Library.)

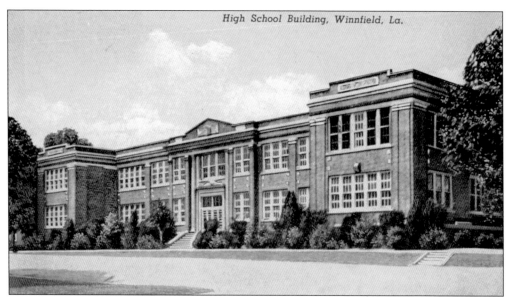

High School Building, Winnfield, La.

After the turn of the century, Winnfield experienced rapid growth. Between 1904 and 1907, the teaching staff at Winnfield High School doubled from 6 to 12. A picnic held at the end of the 1907 school year featured "a great amount of oratory urging construction of a new high school building" to be achieved with a proposed 10-mill tax. The tax issue passed. In this photograph is WHS on South St. John Street. (Courtesy Greggory Davies.)

Calvin began its growth in 1901 with the construction of the Louisiana and Arkansas Railroad and a new sawmill. Residents built a two-story schoolhouse in 1909, with E.C. Bott as principal. Calvin High received accreditation in 1926 under the leadership of R.E. Oxford. L.R. Nelson was principal when the school's modern brick structure was erected in 1929. (Courtesy Louisiana State Library.)

ABOUT THE ORGANIZATION

Winnfield, Louisiana, hometown of Huey P. Long, marked 1993, the centennial celebration of his birth, with a year-long series of special events. Included was the August dedication of the new Winn Parish Museum (which also housed the Louisiana Political Museum and Louisiana Forestry Museum) in the old L&A Depot, which had been relocated from its Highway 34 South location to its current site on Main Street.

The museum would later come under the auspices of the Department of Culture, Recreation and Tourism, Office of State Museums, as the Louisiana Political Museum and the Political Hall of Fame. It has an impressive and ever-growing collection of memorabilia from notable personages from Louisiana's colorful political past and present. "There's more history here in Winn Parish than anywhere else in the state of Louisiana, except maybe New Orleans," says director Carolyn Phillips. "That's what we're dedicated to preserve."

With the objective being to disseminate information about the history of Louisiana politics to the general public, using displays and exhibits when possible and providing research opportunities for education, the museum recognizes new inductees into the hall of fame each January.

The Friends of the Louisiana Political Museum Foundation, a 501(c)(3) nonprofit organization, was created by interested individuals in this community and around the state who believe in and support the historical mission of this museum. The foundation is a nongovernmental body with no oversight authority of museum policies. The foundation works as an arm of support for the museum, and monies gathered through fundraisers, annual memberships, and projects (like this book) are available to support museum activities.

www.arcadiapublishing.com

Discover books about the town where you grew up, the cities where your friends and families live, the town where your parents met, or even that retirement spot you've been dreaming about. Our Web site provides history lovers with exclusive deals, advanced notification about new titles, e-mail alerts of author events, and much more.

Arcadia Publishing, the leading local history publisher in the United States, is committed to making history accessible and meaningful through publishing books that celebrate and preserve the heritage of America's people and places. Consistent with our mission to preserve history on a local level, this book was printed in South Carolina on American-made paper and manufactured entirely in the United States.

This book carries the accredited Forest Stewardship Council (FSC) label and is printed on 100 percent FSC-certified paper. Products carrying the FSC label are independently certified to assure consumers that they come from forests that are managed to meet the social, economic, and ecological needs of present and future generations.

FSC
Mixed Sources
Product group from well-managed forests and other controlled sources

Cert no. SW-COC-001530
www.fsc.org
© 1996 Forest Stewardship Council

Find Your Place in History.